Tibetan Lettering & Tattoo Design

Copyright © 2011 South Seas Dharma
ISBN 978-1-105-32128-3
Published by South Seas Dharma Publications
All rights reserved. Except for usage as actual tattoos,
no part of this publication may be reproduced, stored in
a retrieval system, or transmitted in any form by any means,
electronic, mechanical, photocopying, recording or otherwise
without the expressed written consent from the publisher.
Requests may be sent to SouthSeasDharma@gmail.com

The lettering in this book is known as Tibetan Uchen script. All of the script in this book was hand drawn. It is presented in various ways stylistically to illustrate how personal style can affect presentation without changing the word meaning. This book is intended for reference purposes only- the reader is encouraged to use the illustrations and lettering guide to come up with their own designs with their own unique style. No portion of this book may be used for any commercial purposes whatsoever.

Support the Arts and Charity- Please Do Not Reproduce this Book

20% of the proceeds from this book will be donated to charities benefitting the people of Tibet. By unlawfully reproducing this book you are doing a dis-service to the author, the publisher, people in need, and yourself. For a list of the charities and charitable works we are involved in, feel free to e-mail us at: SouthSeasDharma@gmail.com

Acknowledgements:

For help with translations, proofreading and support,
Many Thanks are in order to the following:

Dorje Karpo, Geshe Thupten Kunkhen, Tsepak Rigzin, Melvyn Goldstein and Yeshe Phelgey
Many Thanks for support and guidance also goes to Geshe Ngawang Phende, Geshe Damdul Namgyal, Kyabje Denma Locho Rinpoche, H.E.Ganden Tripa Rizong Rinpoche, Lobsang Tenzin, Mike Donovan, Farisa Belson, Josh May and Scott Shetler

For inspiration and reference, immense gratitude must be extended to:
Singh Bahadur Lama, Sanje Elliot, Robert Beer, Tashi Mannox, Chogyam Trungpa, Dzongsar Jamyang Khyenste, and of course
H.H. XVII Karmapa Ogyen Trinley Dorje and H.H. XIV Dalai Lama Tenzin Gyatso

-Ngawang Samten, 2011

Table of Contents:

The Alphabet..1

Popular Words/Phrases..4

Mudras...24

Eight Auspicious Symbols...35

Mantras..44

Mani Mantra..56

The Tibetan Alphabet

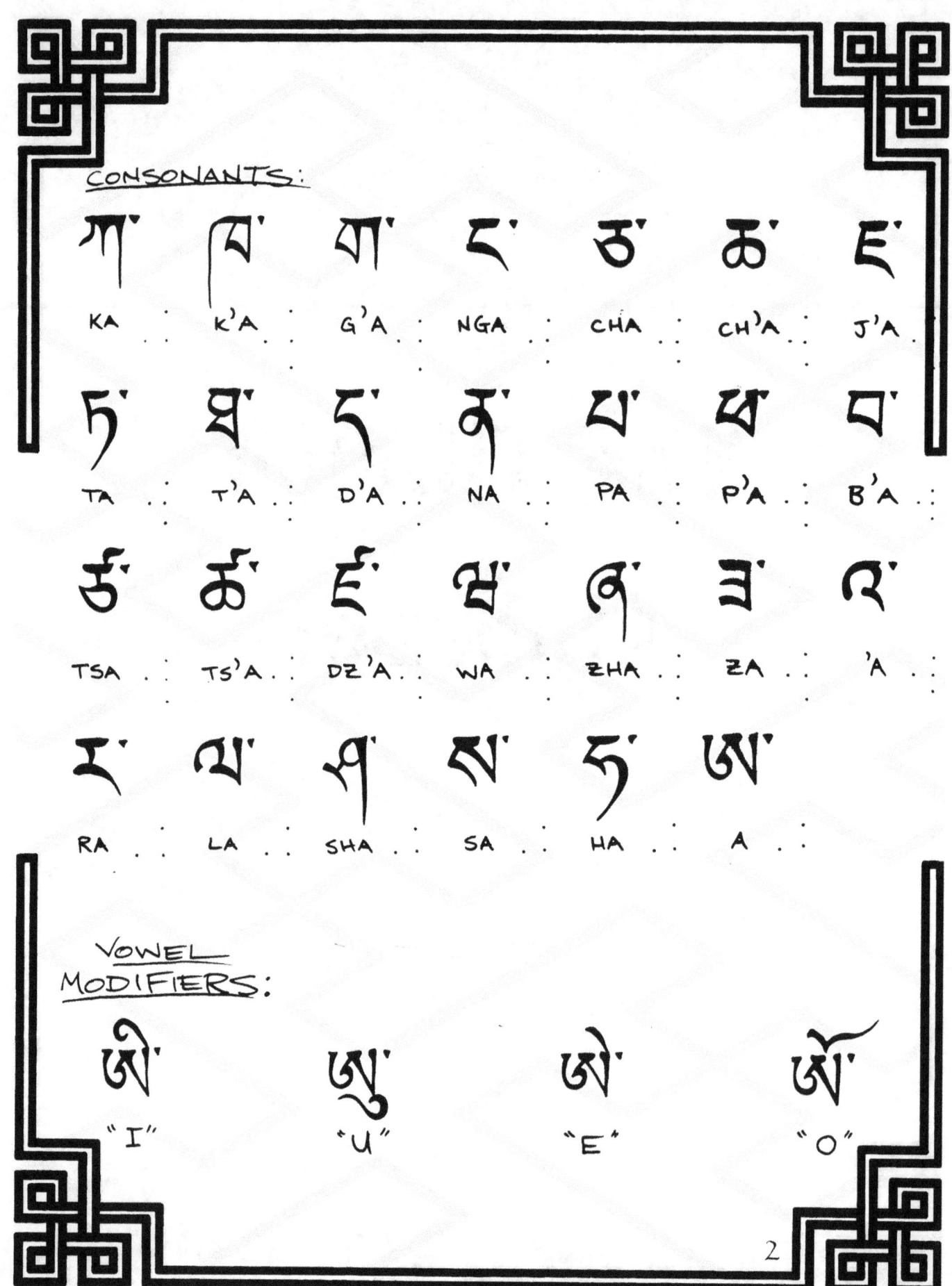

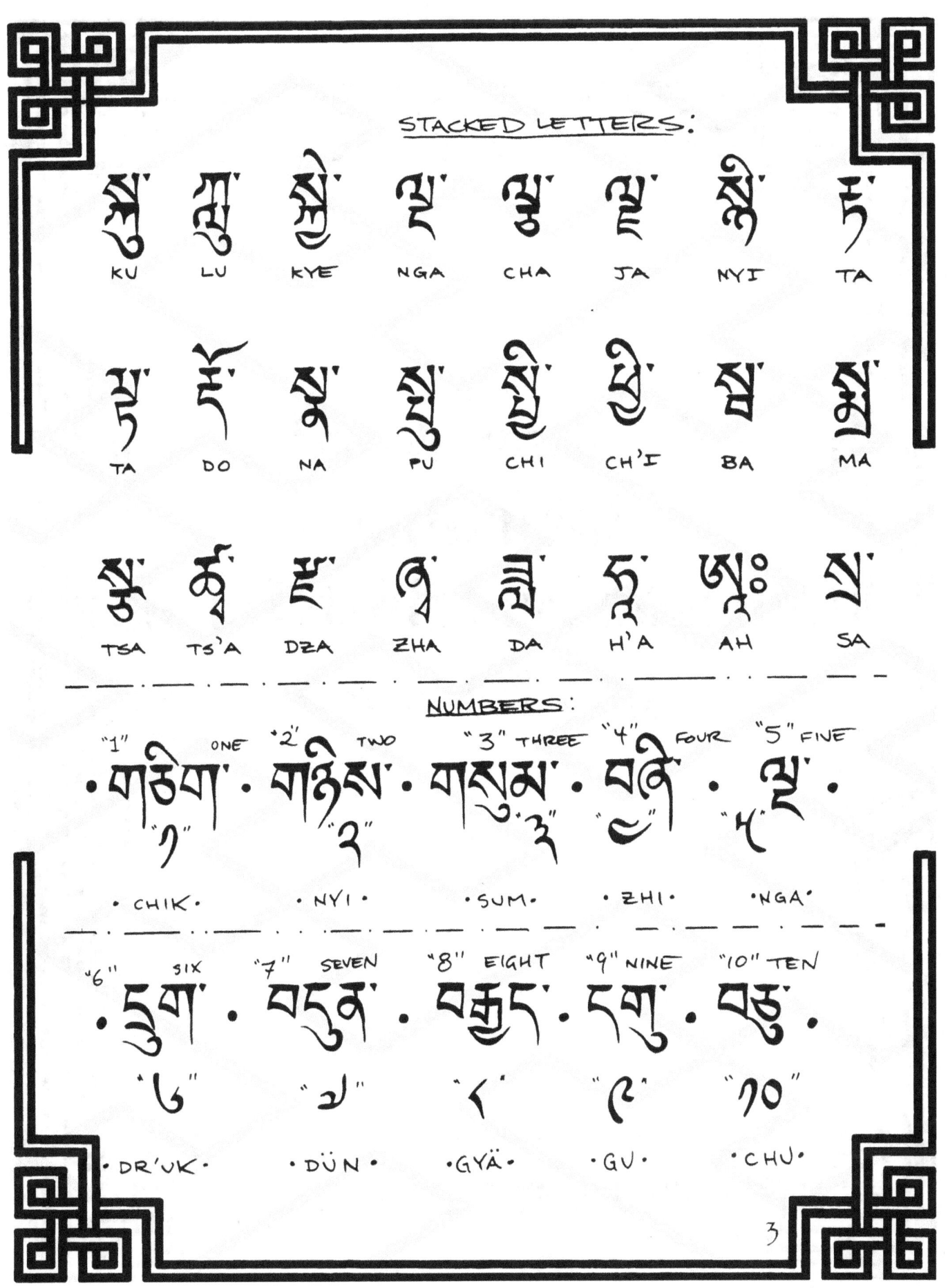

Popular Words, including Common Buddhist Terms and Phrases

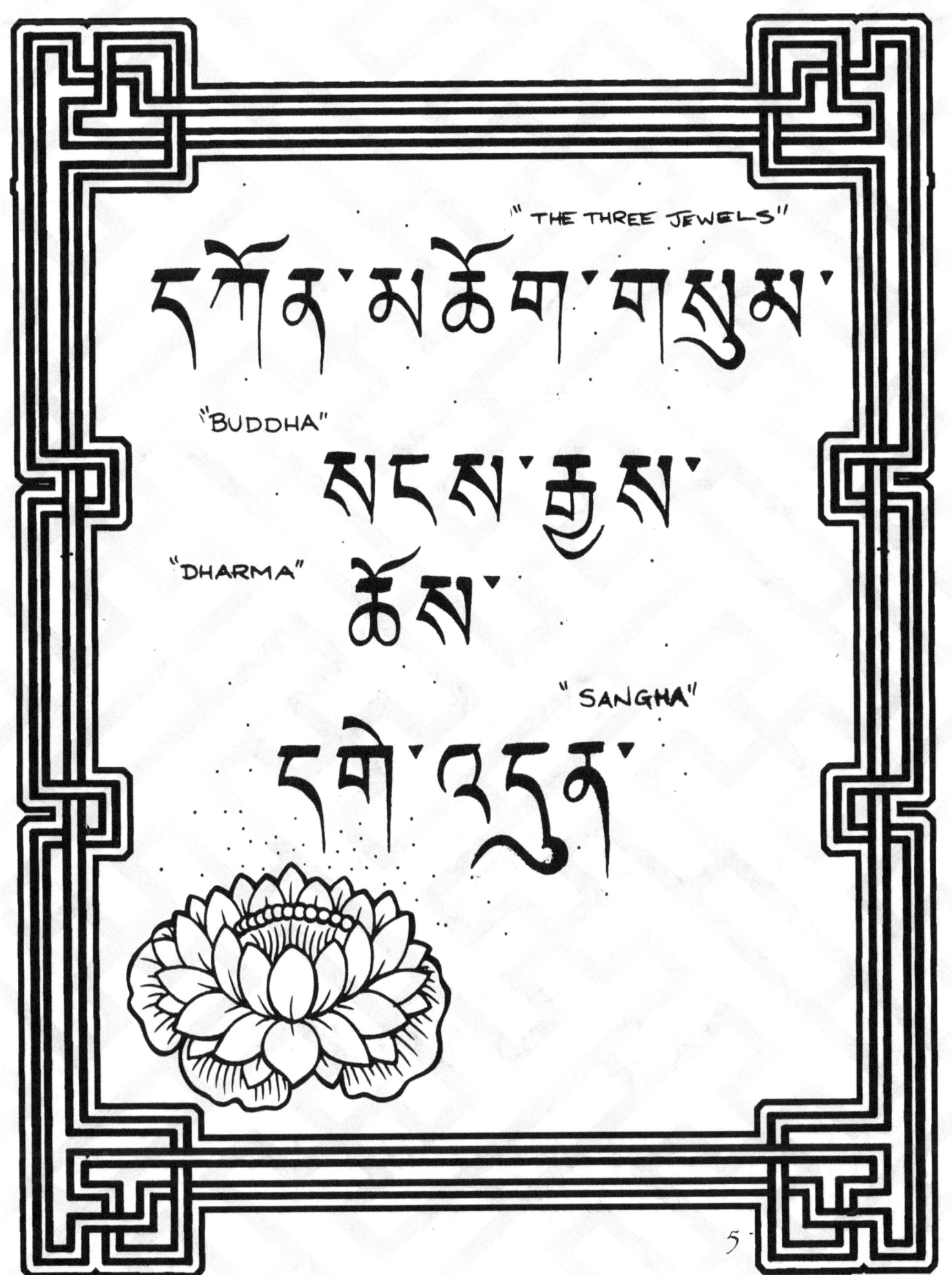

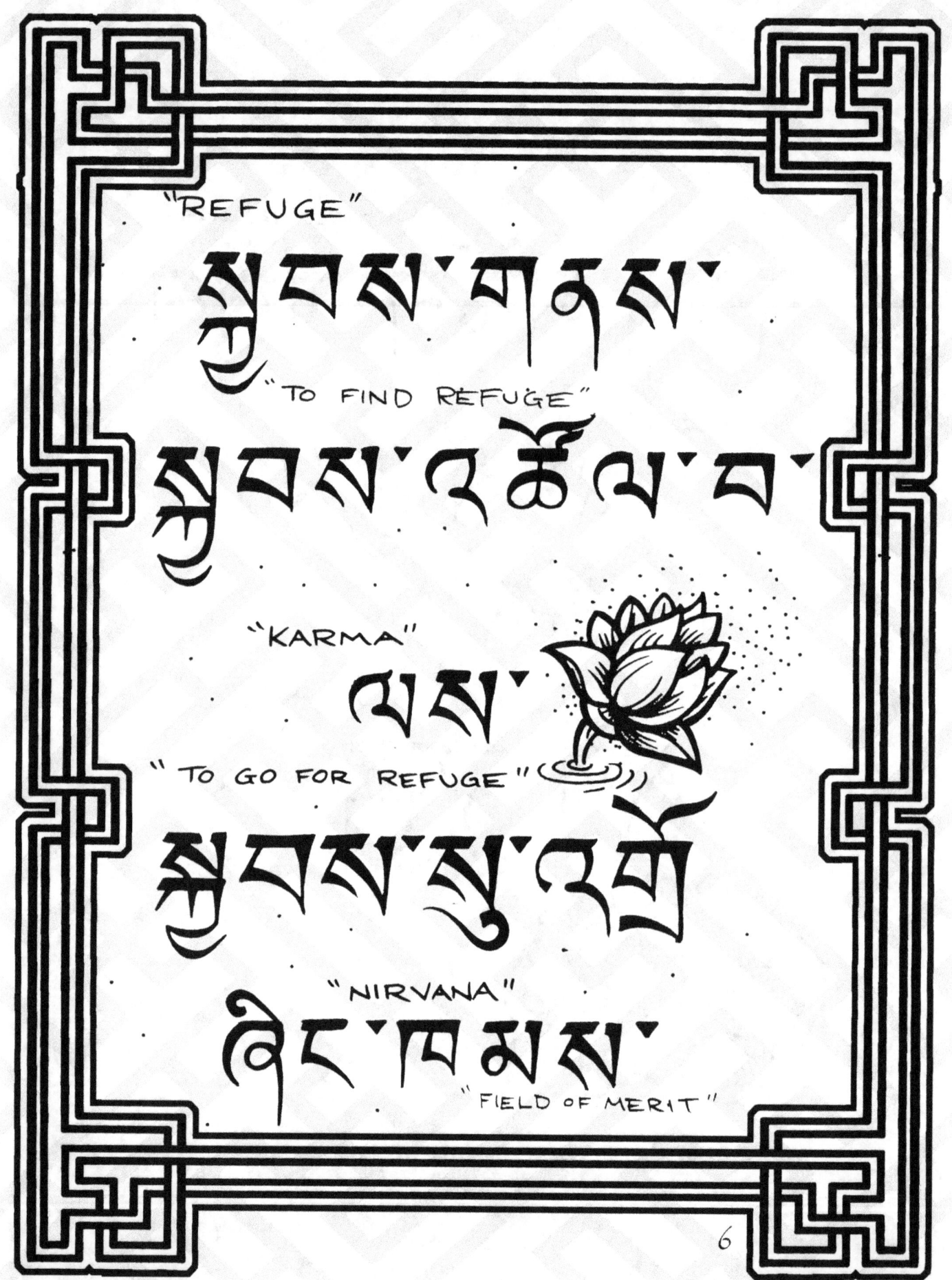

"REFUGE"

སྐྱབས་གནས་

"TO FIND REFUGE"

སྐྱབས་འཚོལ་བ་

"KARMA"

ལས་

"TO GO FOR REFUGE"

སྐྱབས་སུ་འགྲོ་

"NIRVANA"

ཞིང་ཁམས་

"FIELD OF MERIT"

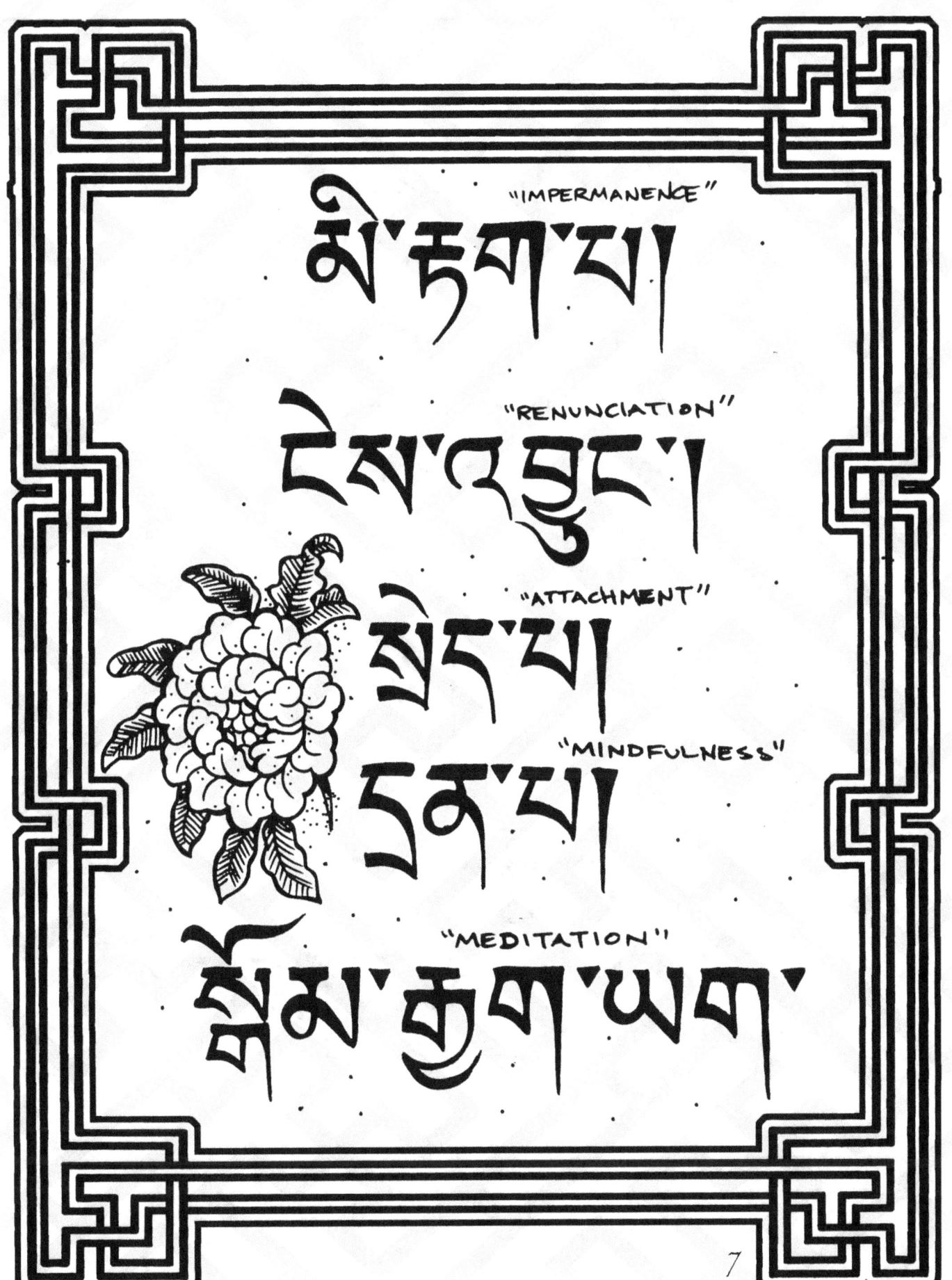

WISDOM (KNOWLEDGE)

ཤེས་རབ་

"WISDOM"/"INNER KNOWLEDGE"

ནང་ཤེས

"WISDOM"

ཡེ་ཤེས

"LOVE"

བརྩེ་བ་ བརྩེ་བོ

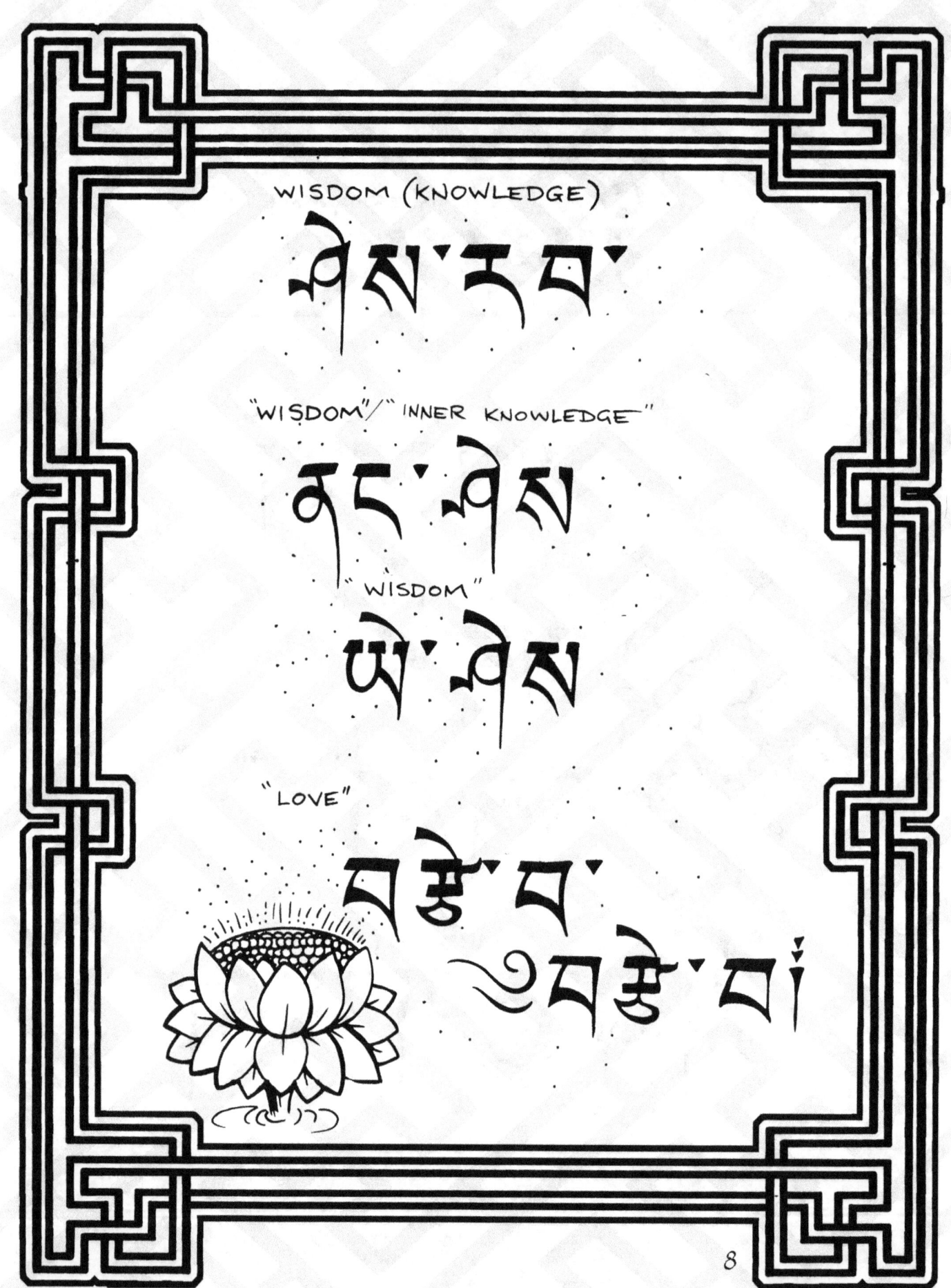

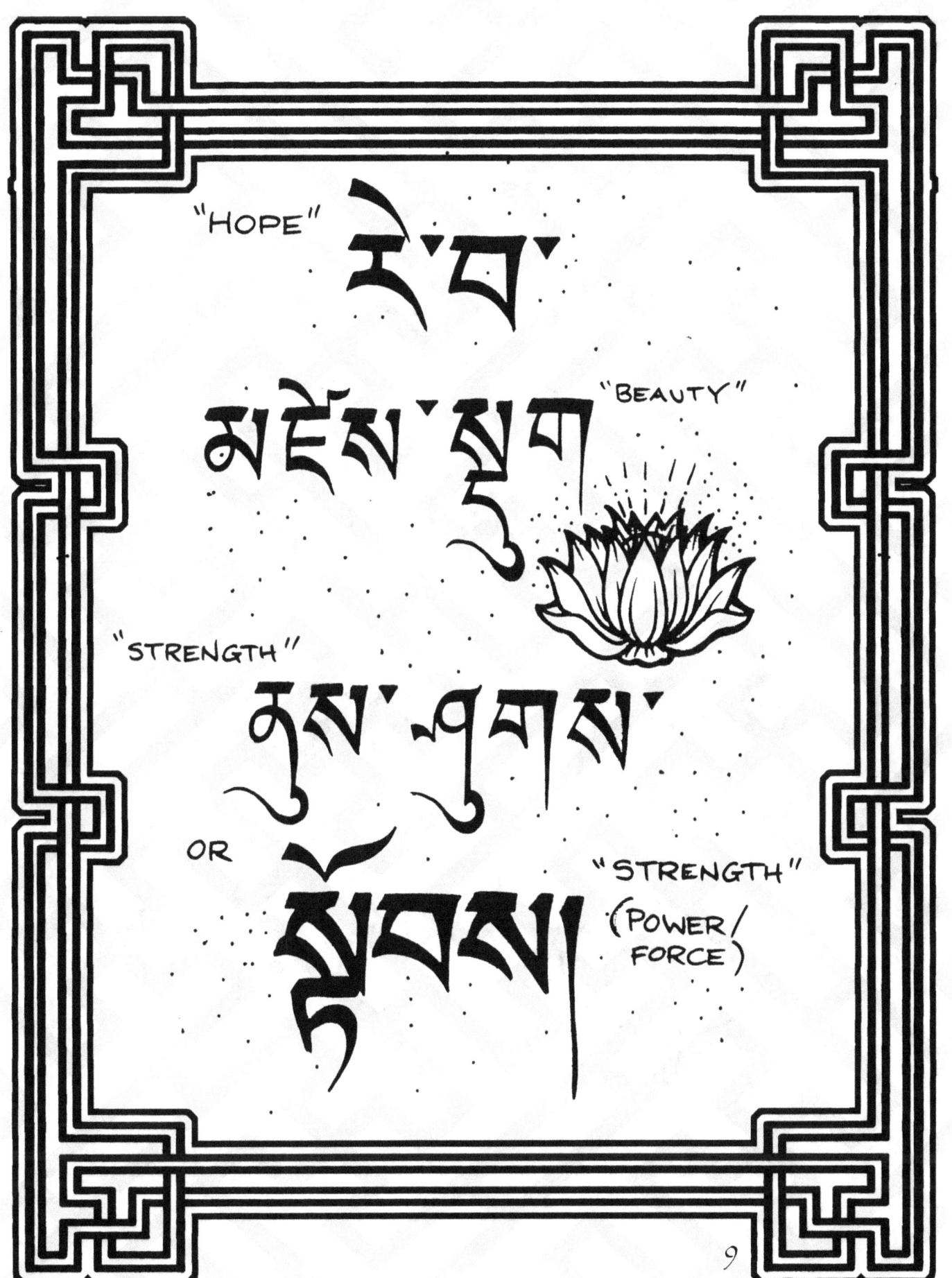

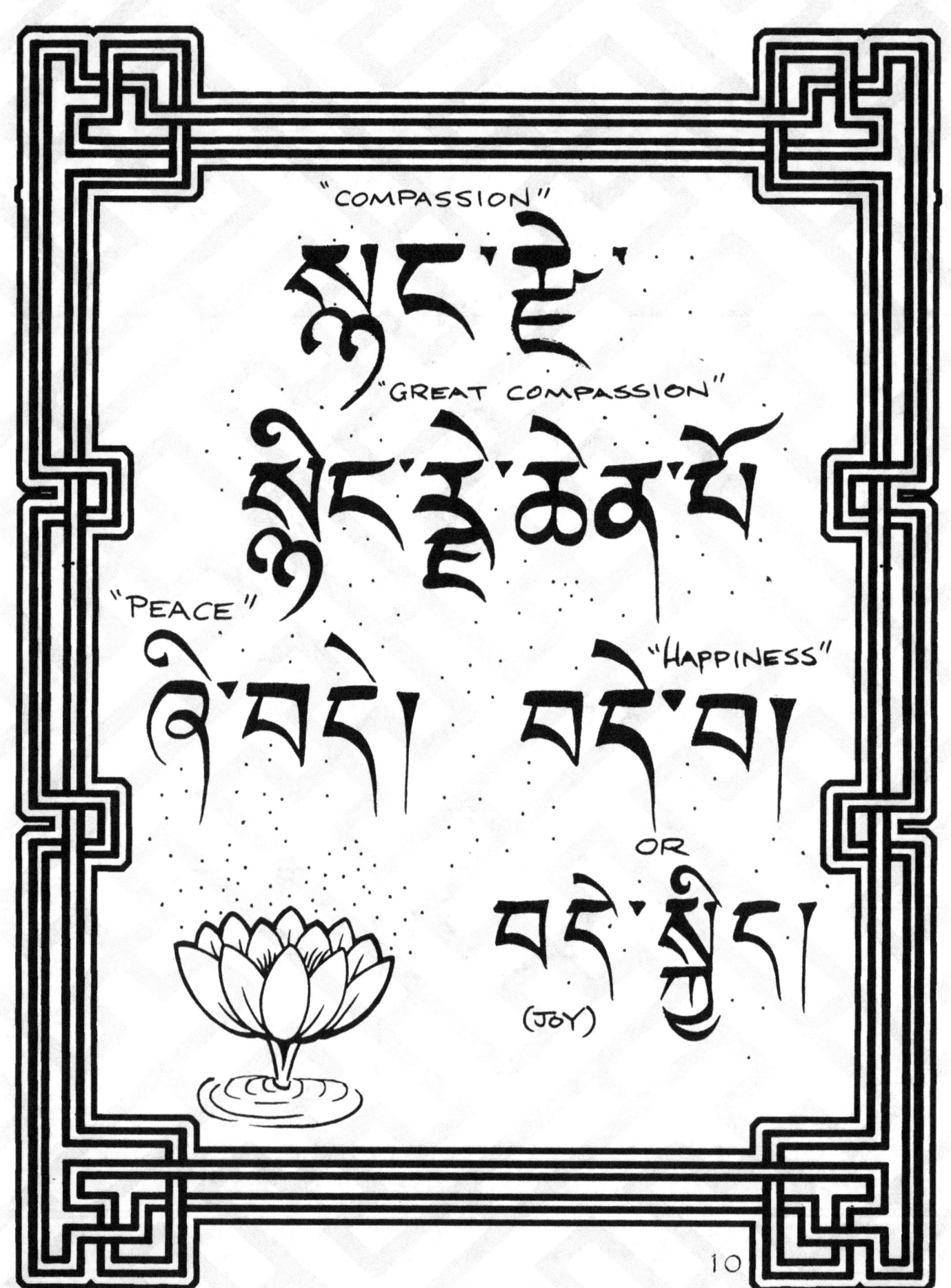

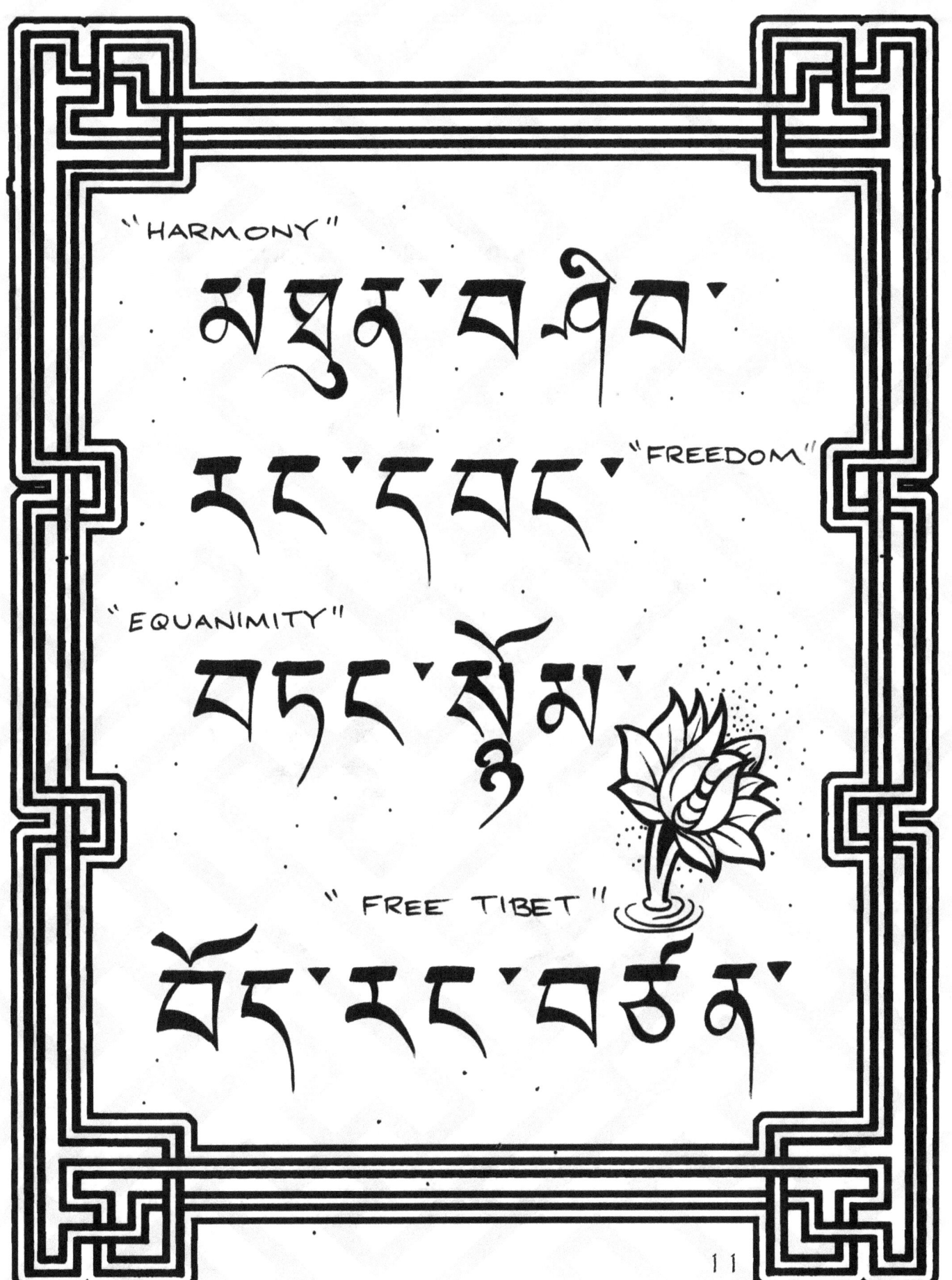

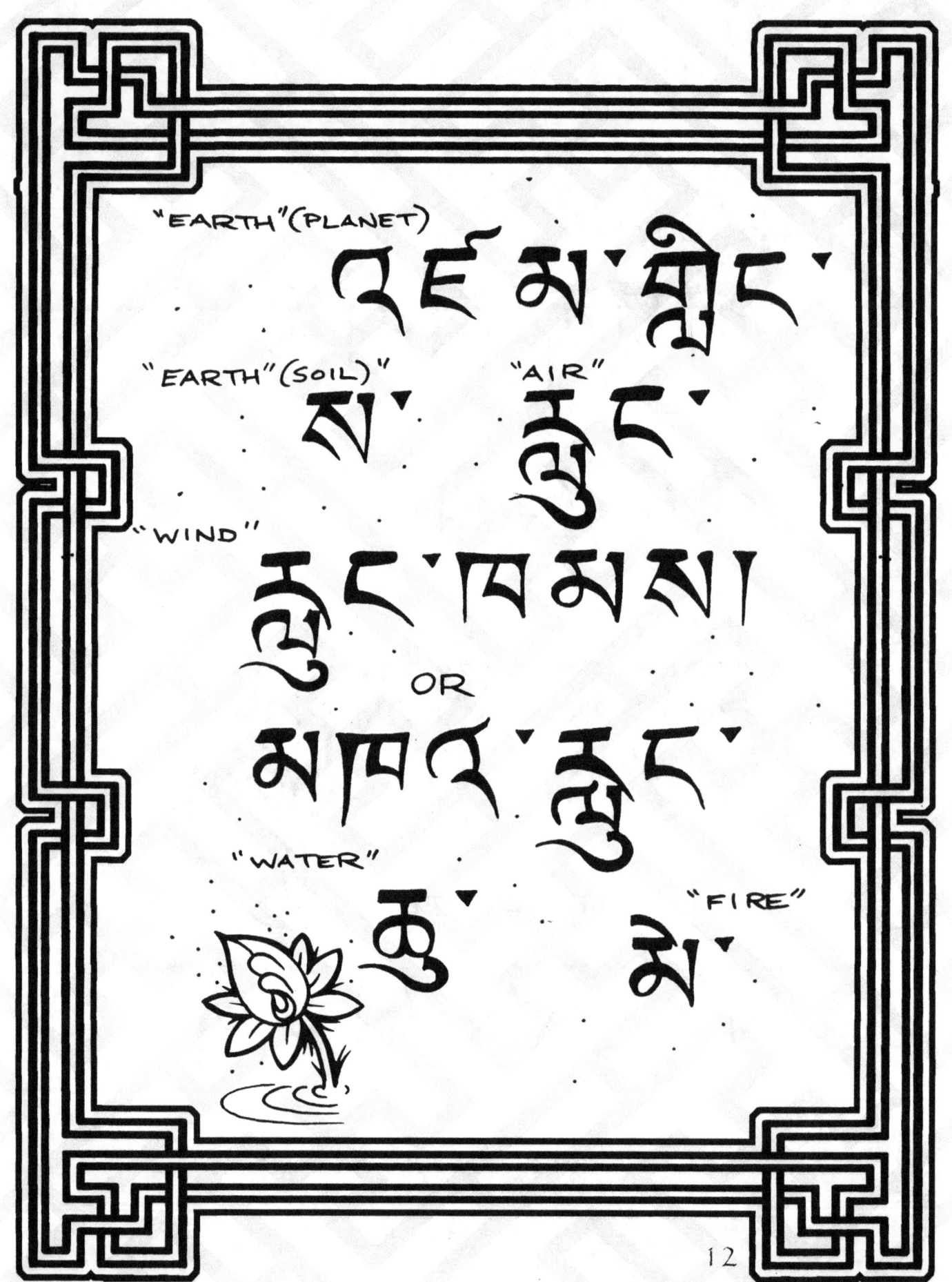

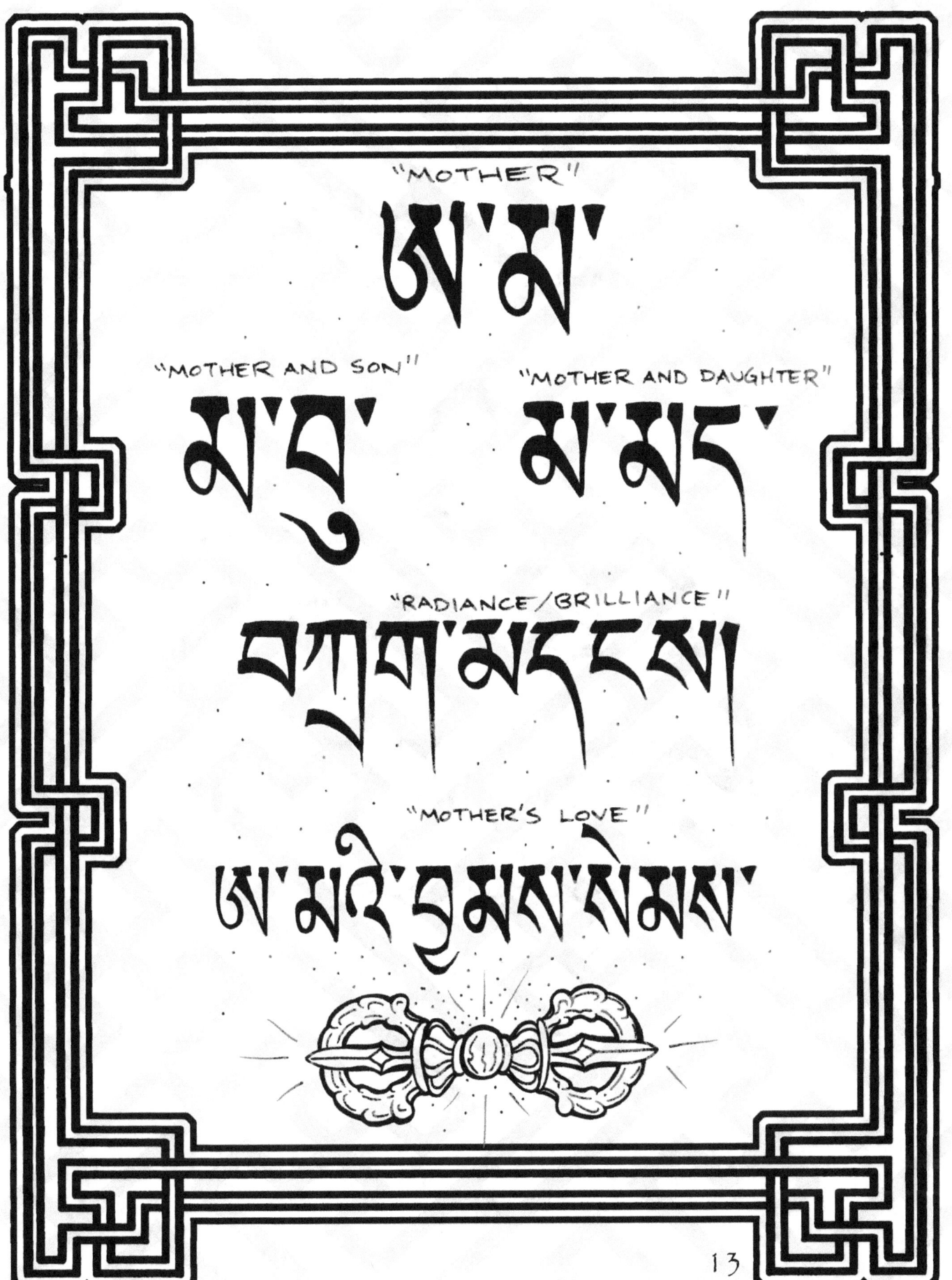

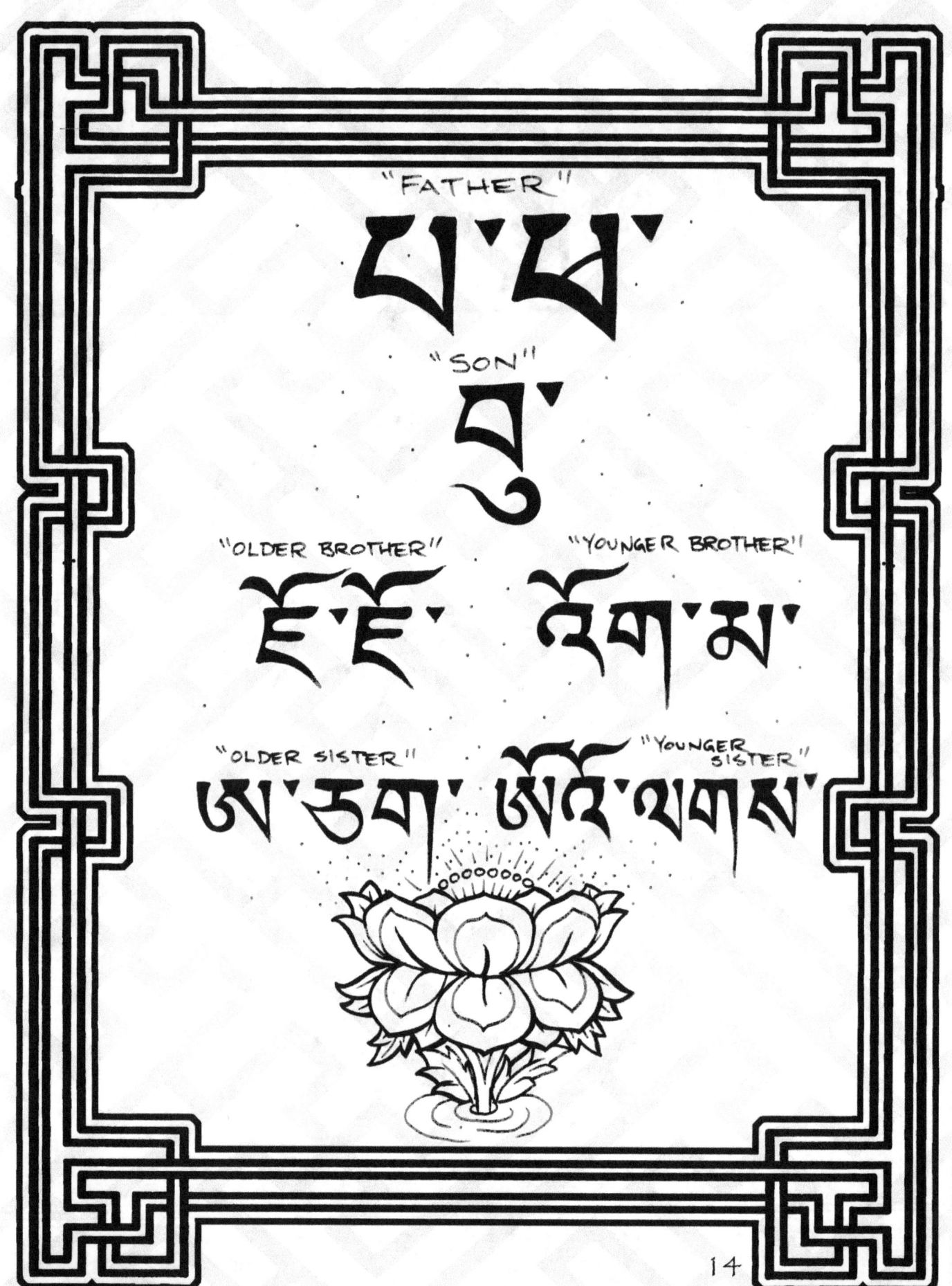

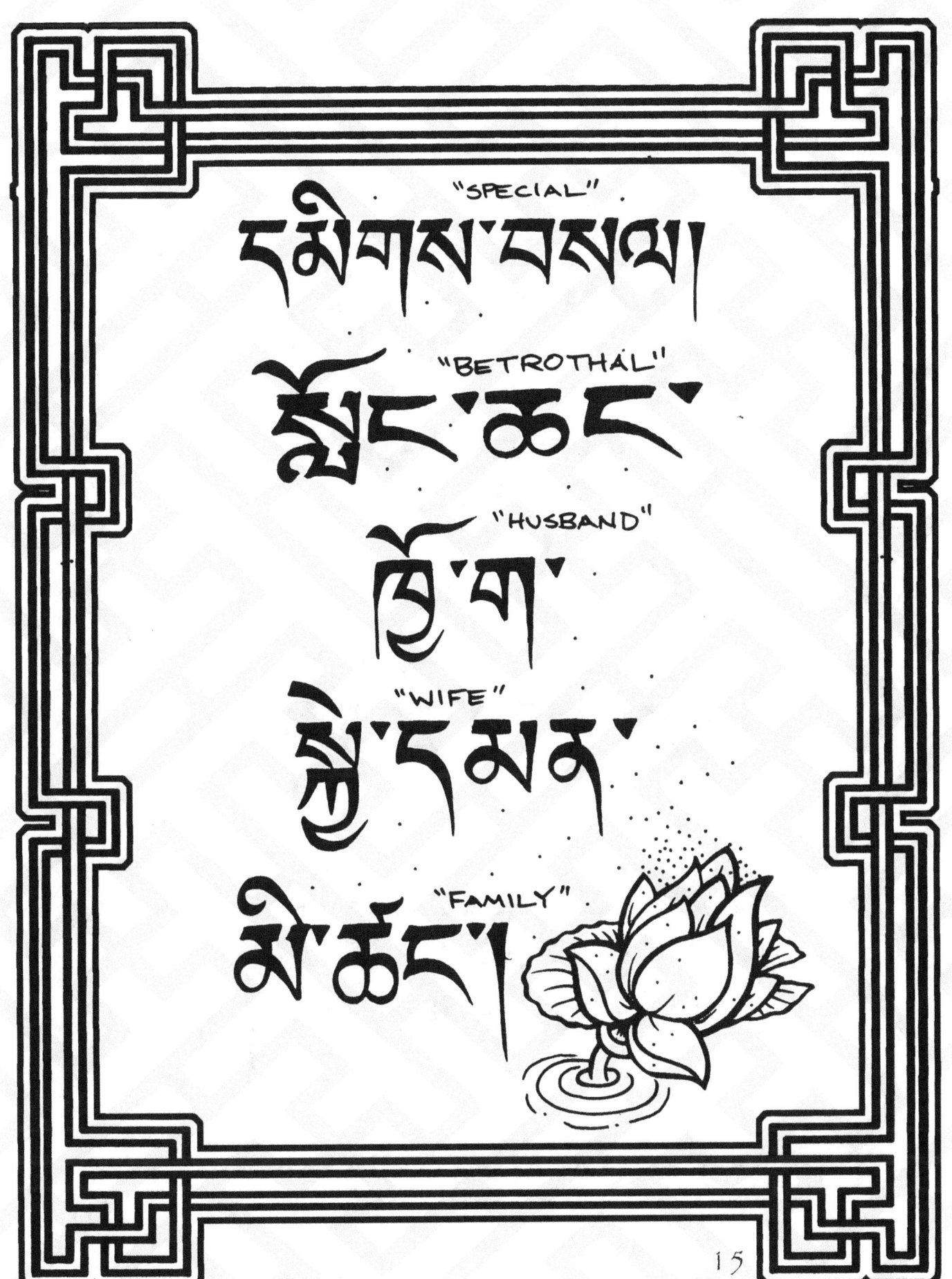

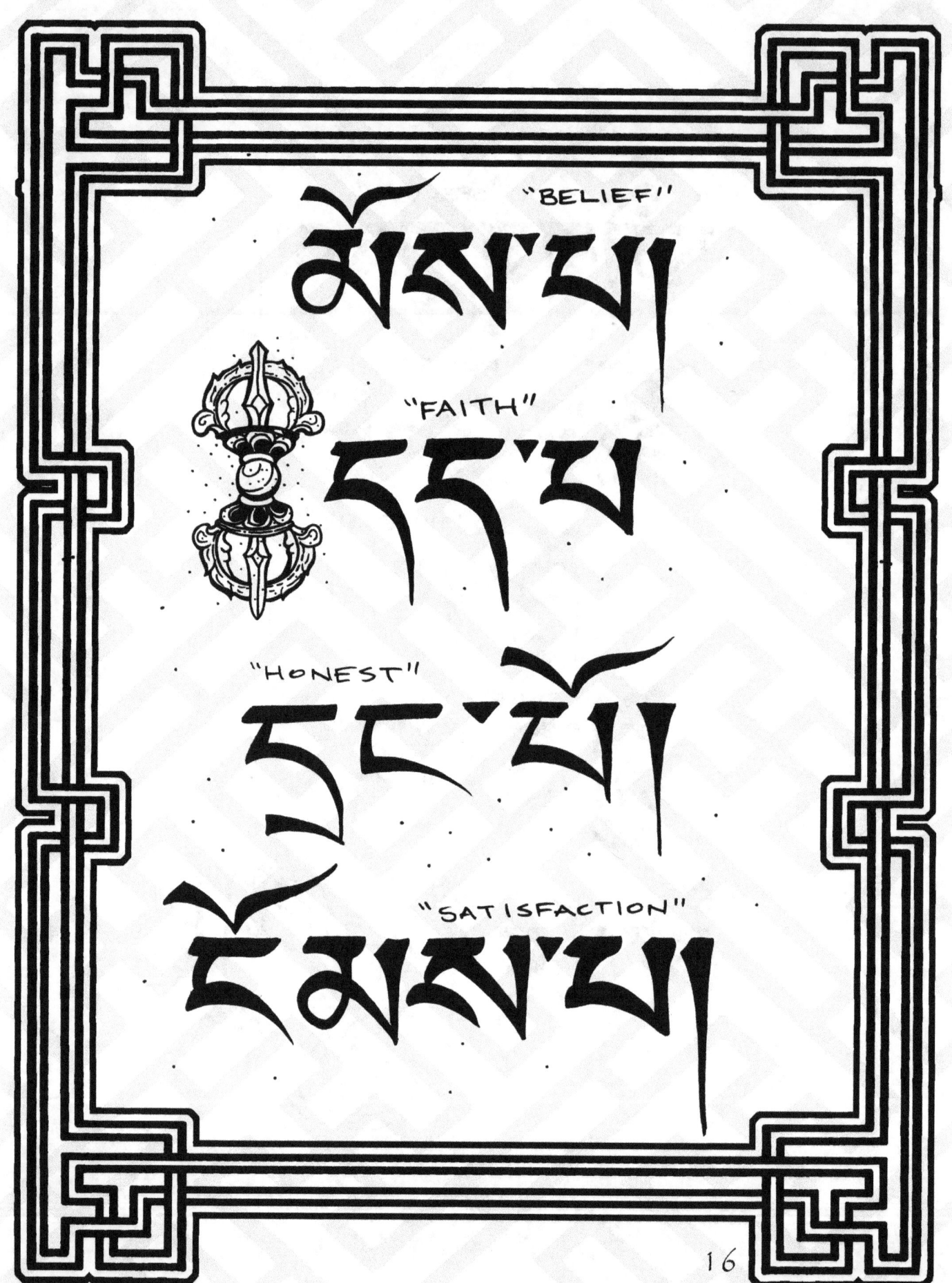

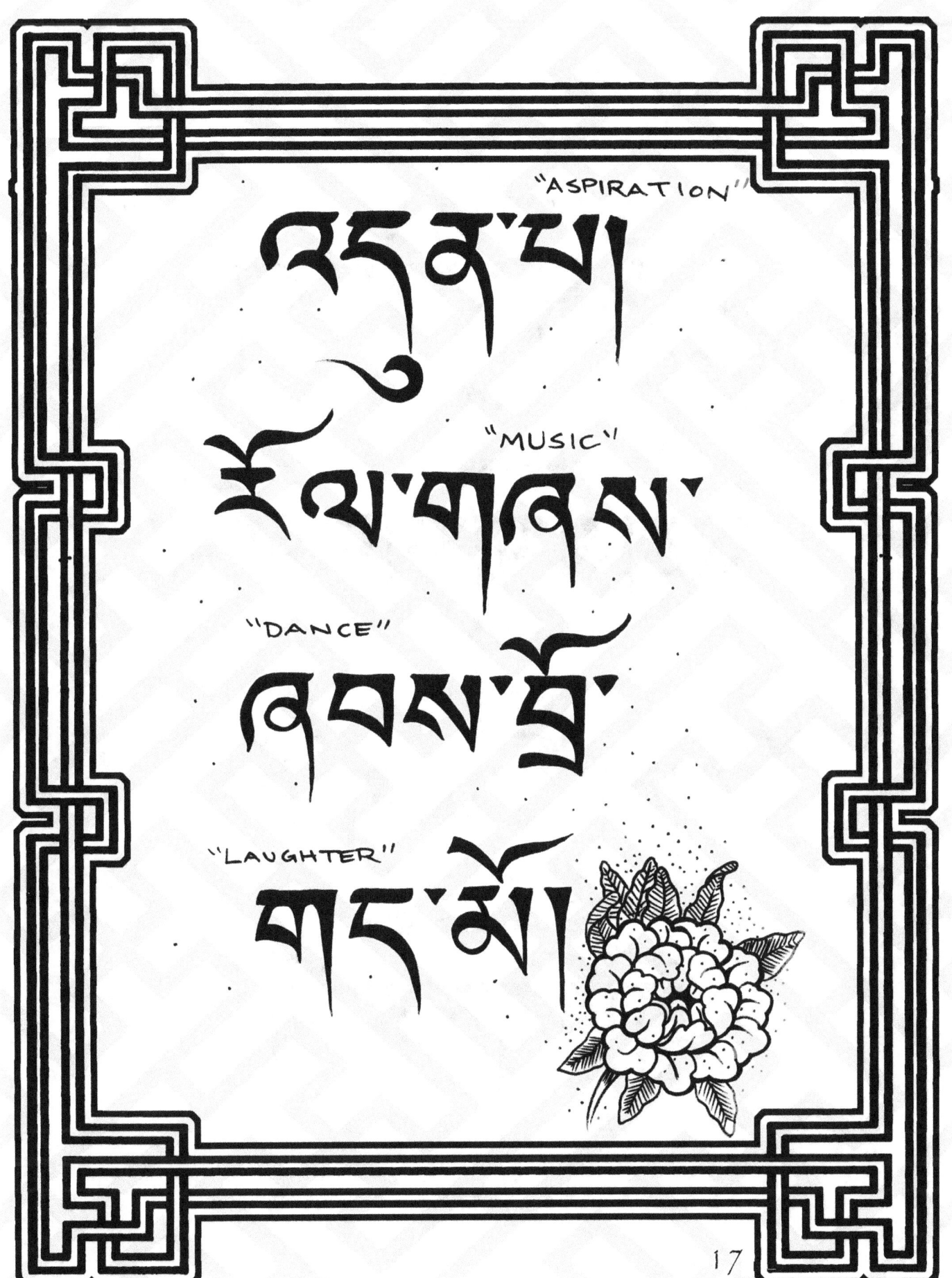

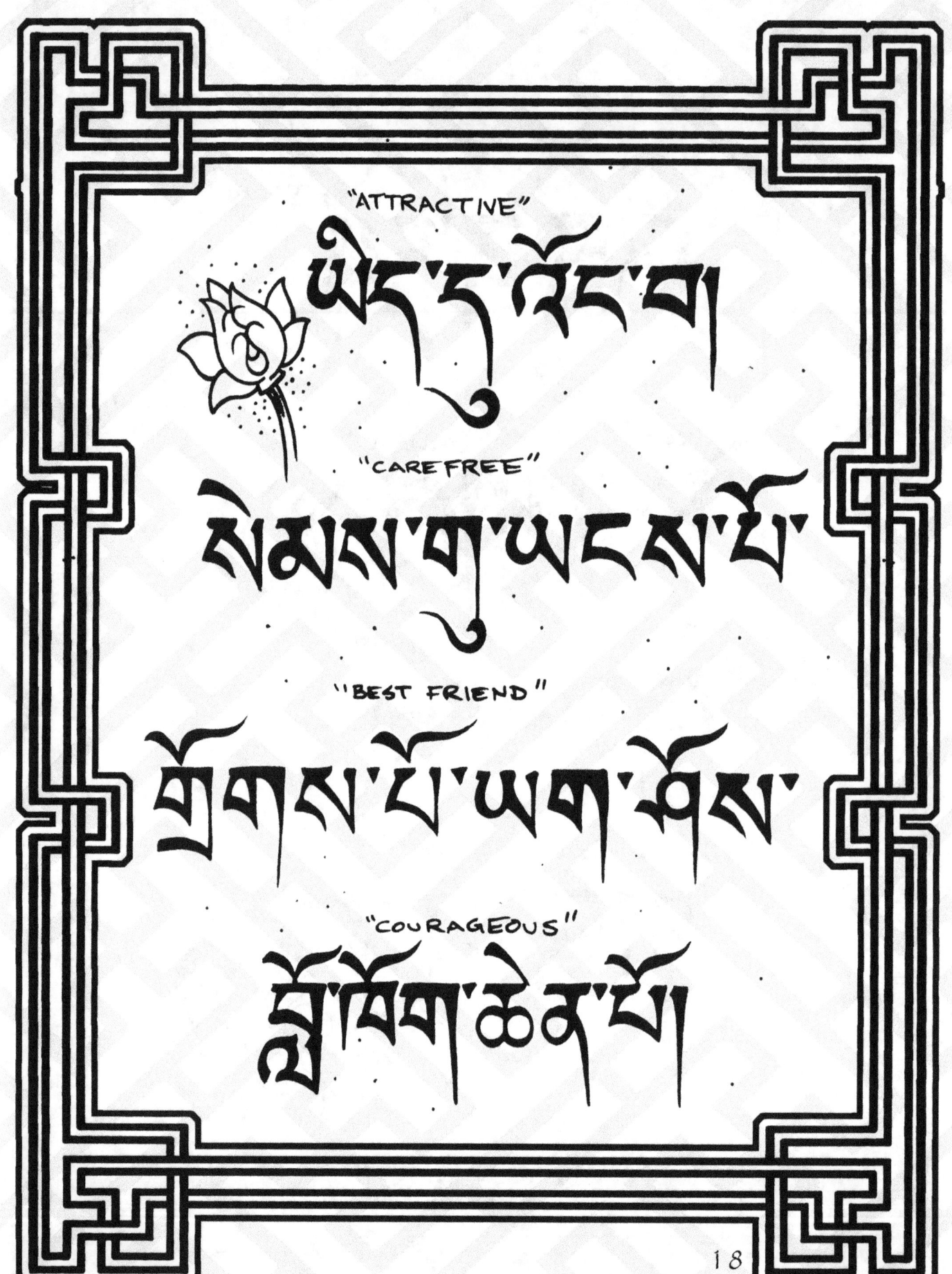

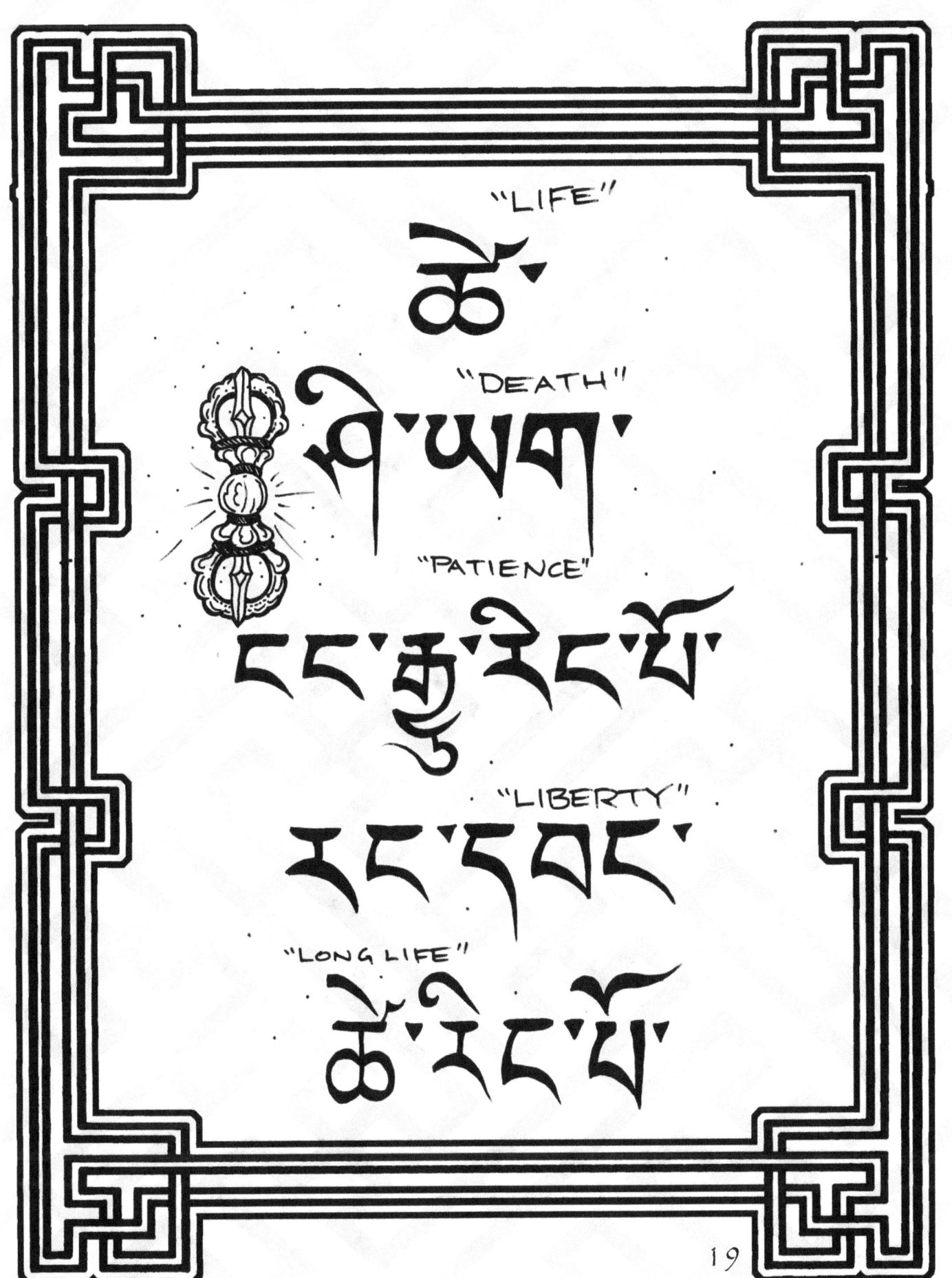

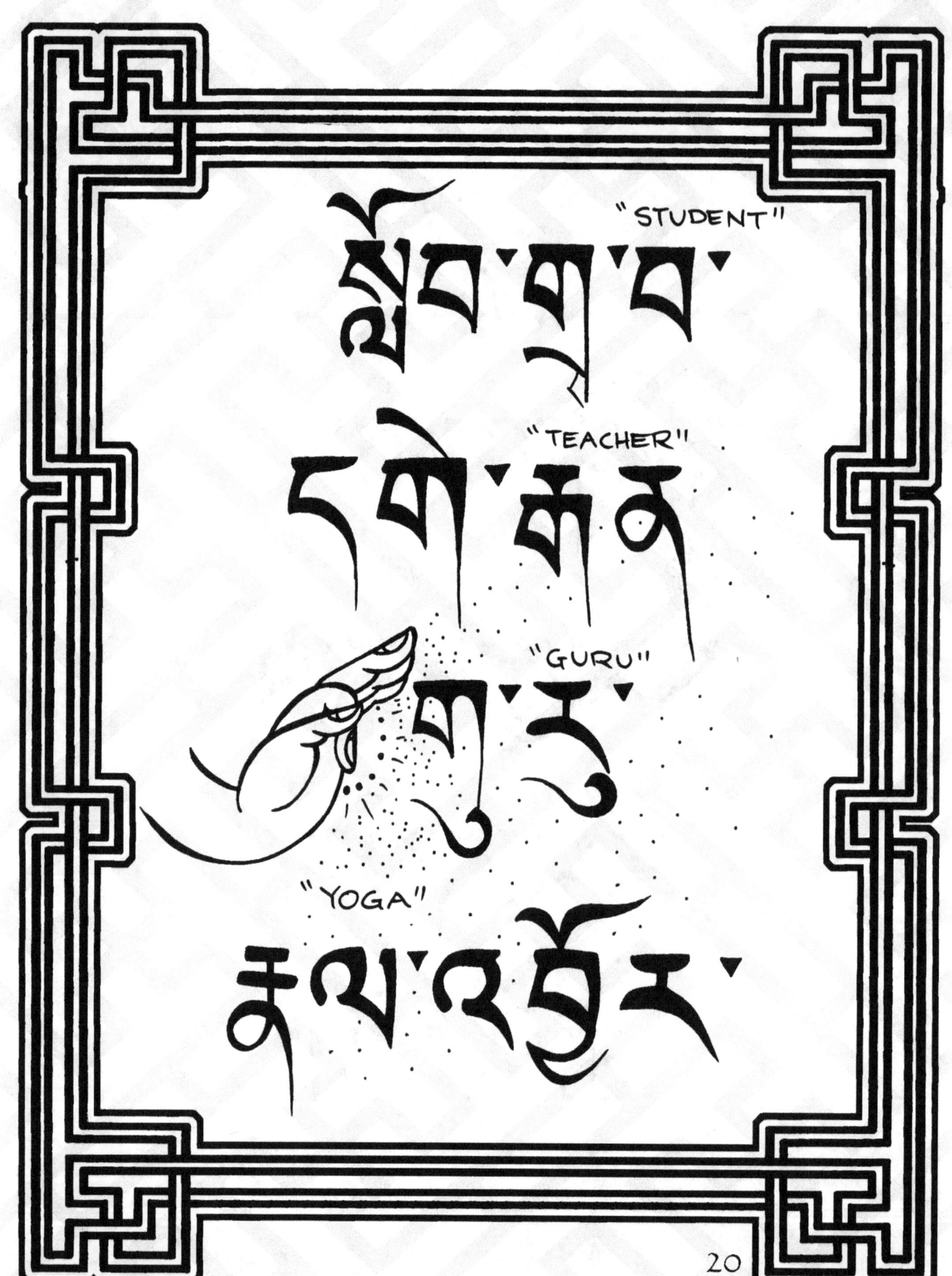

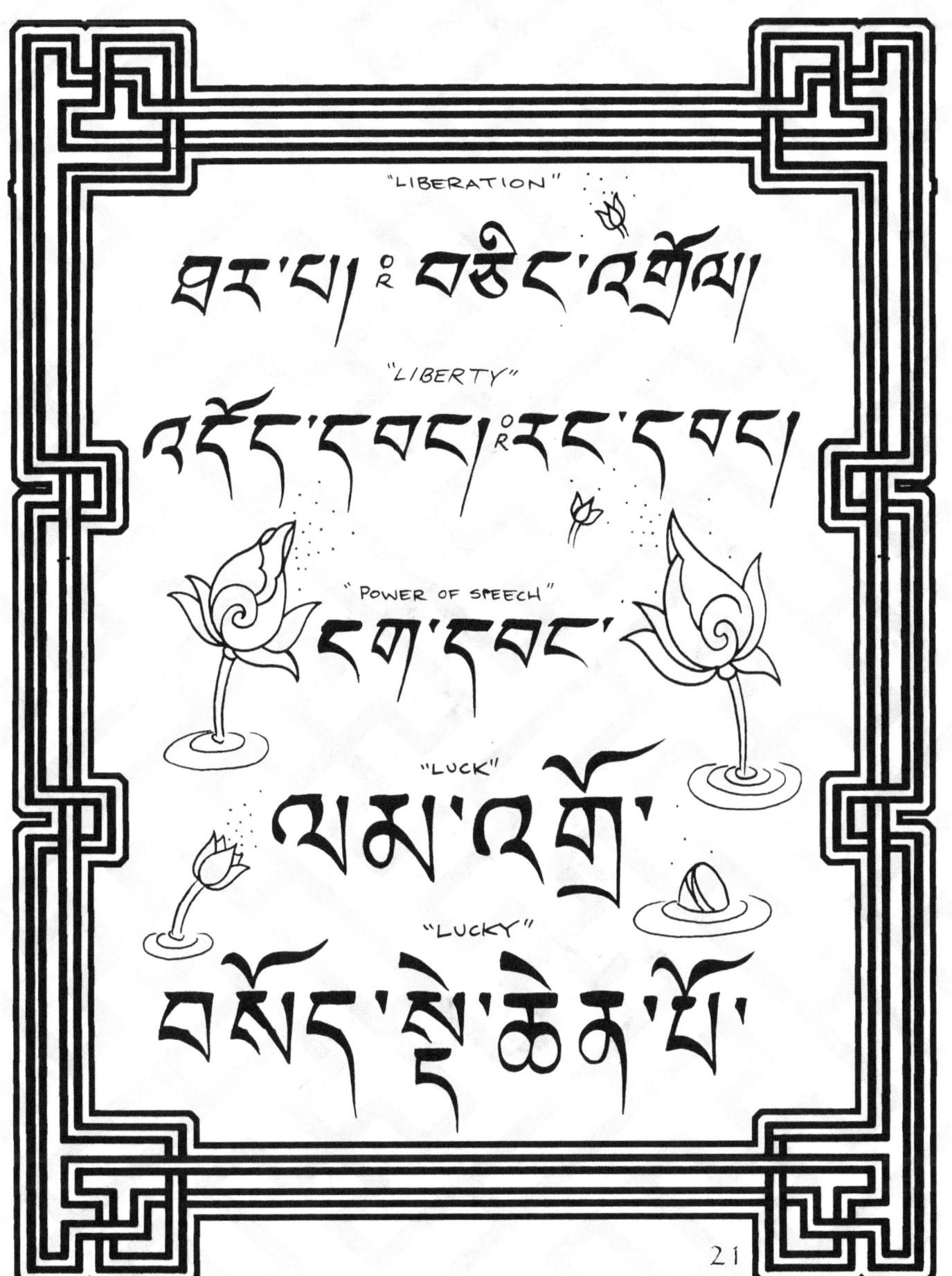

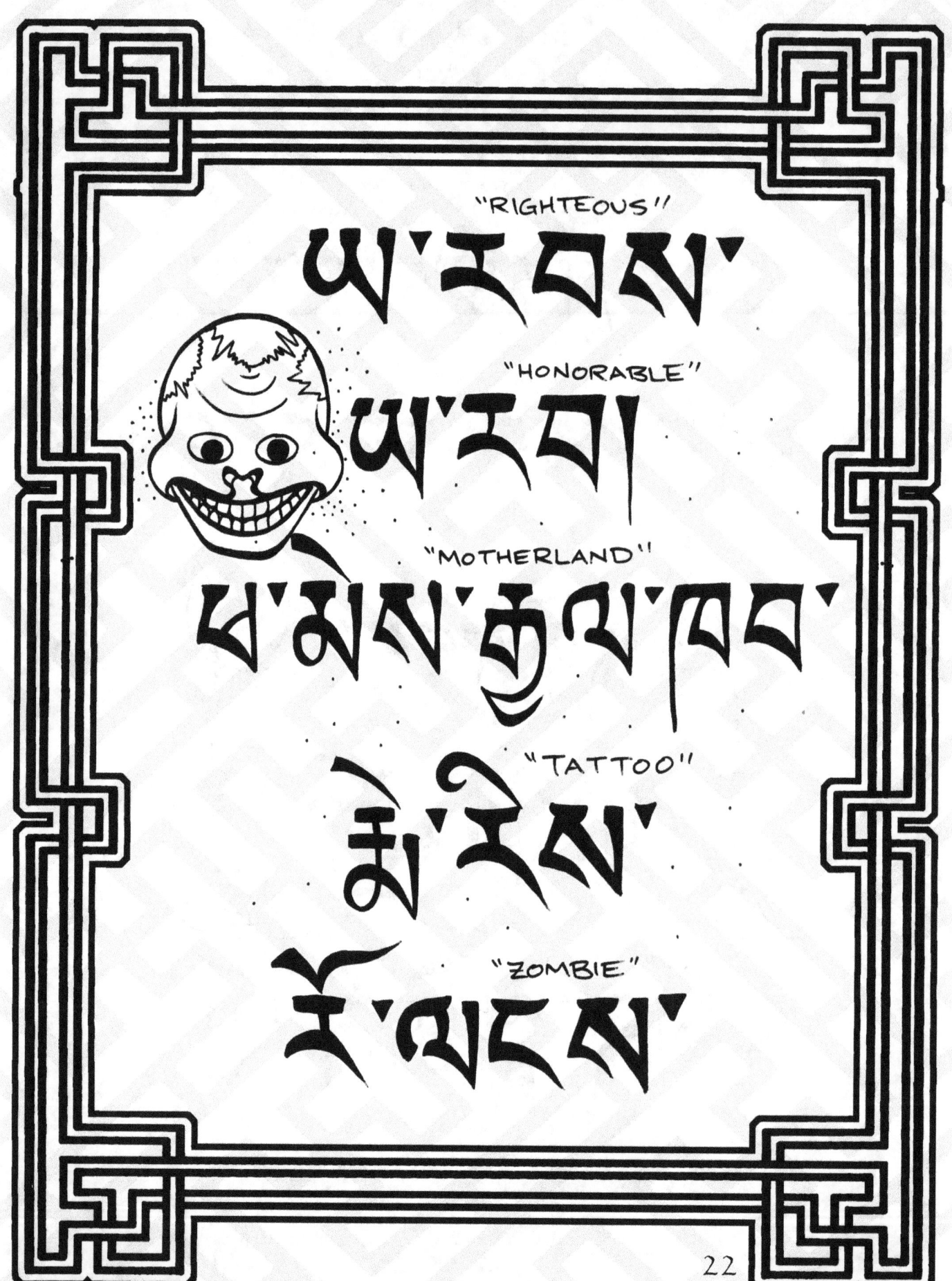

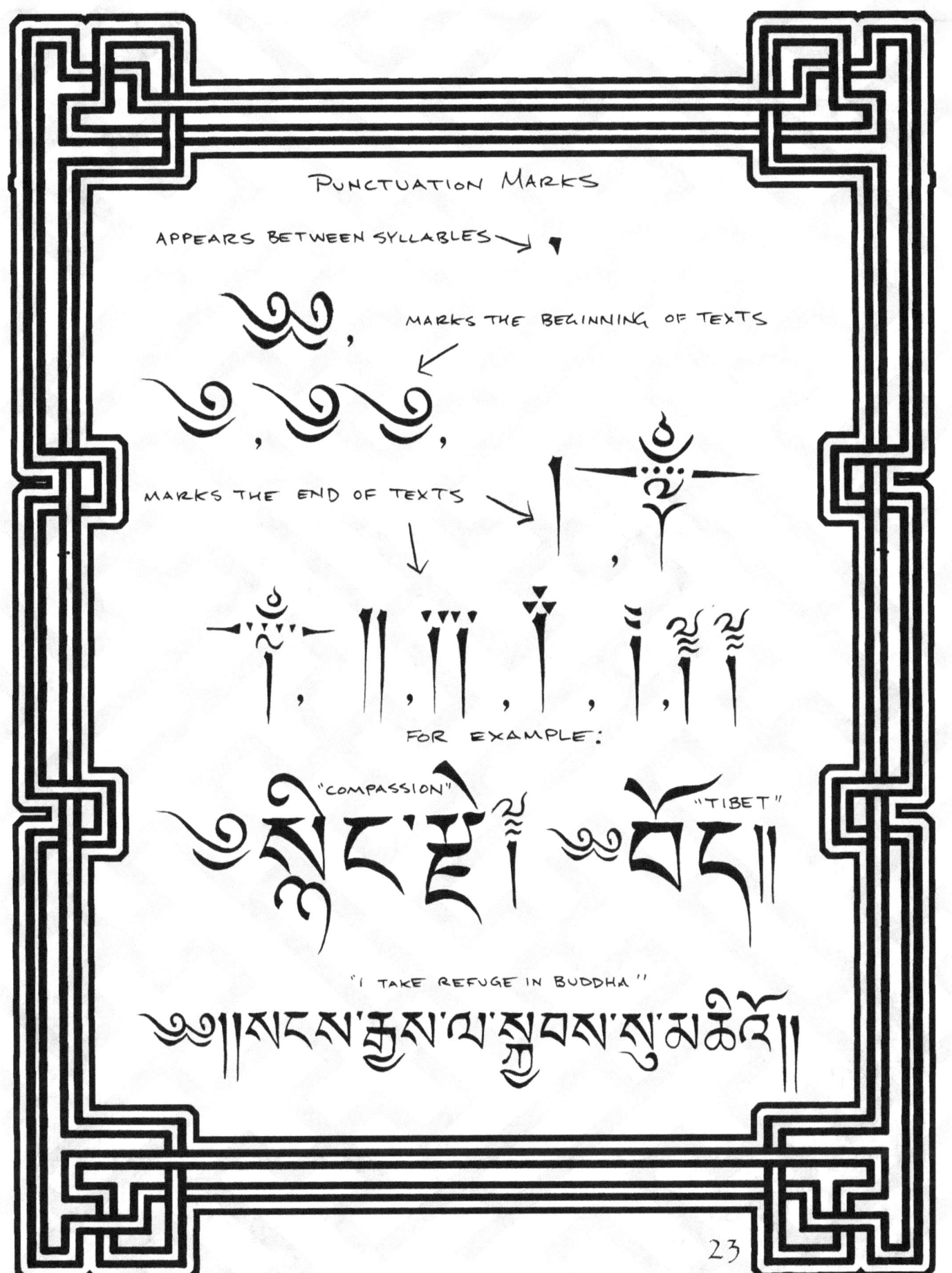

Mudras
(Hand Gestures)

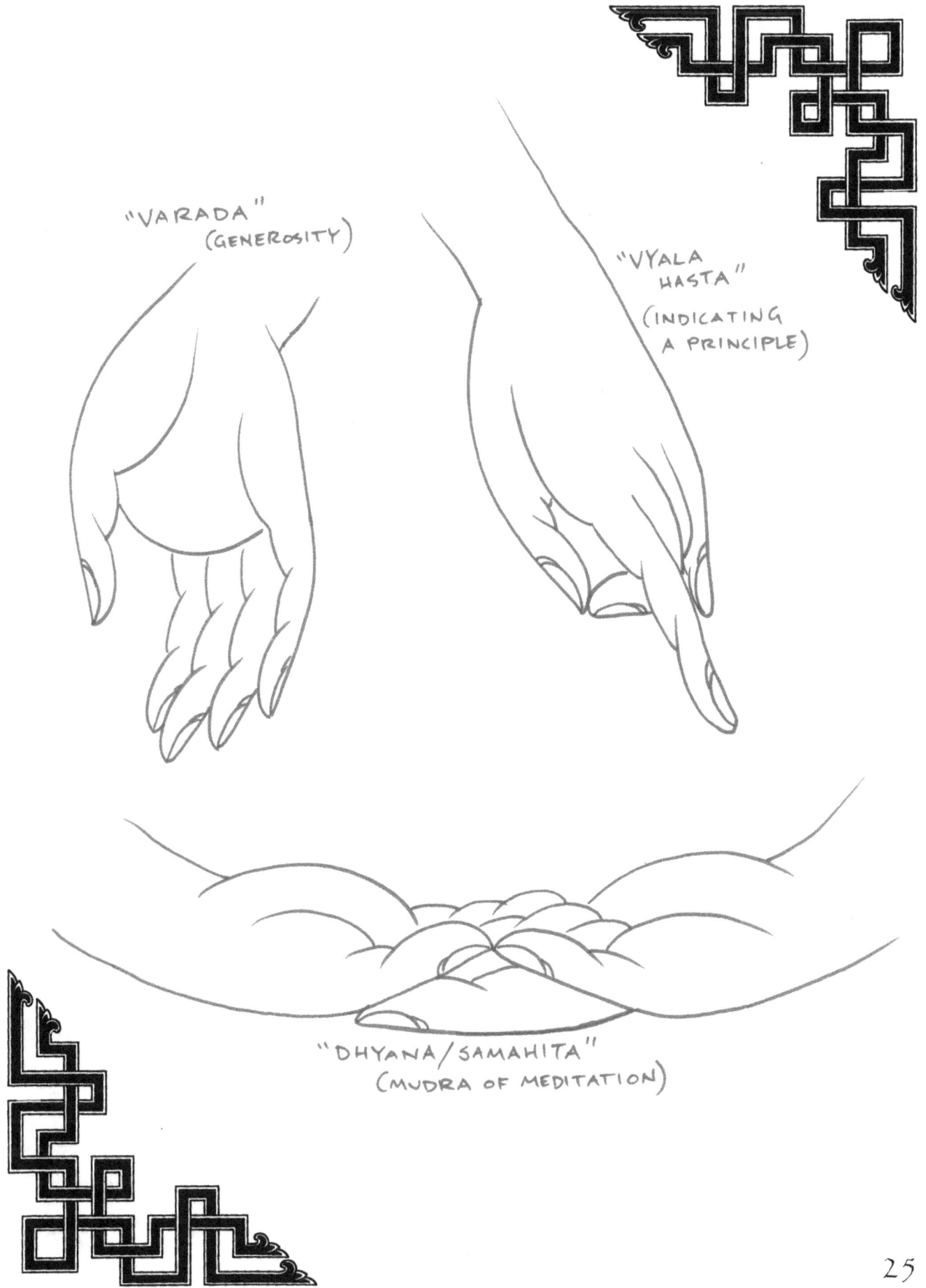

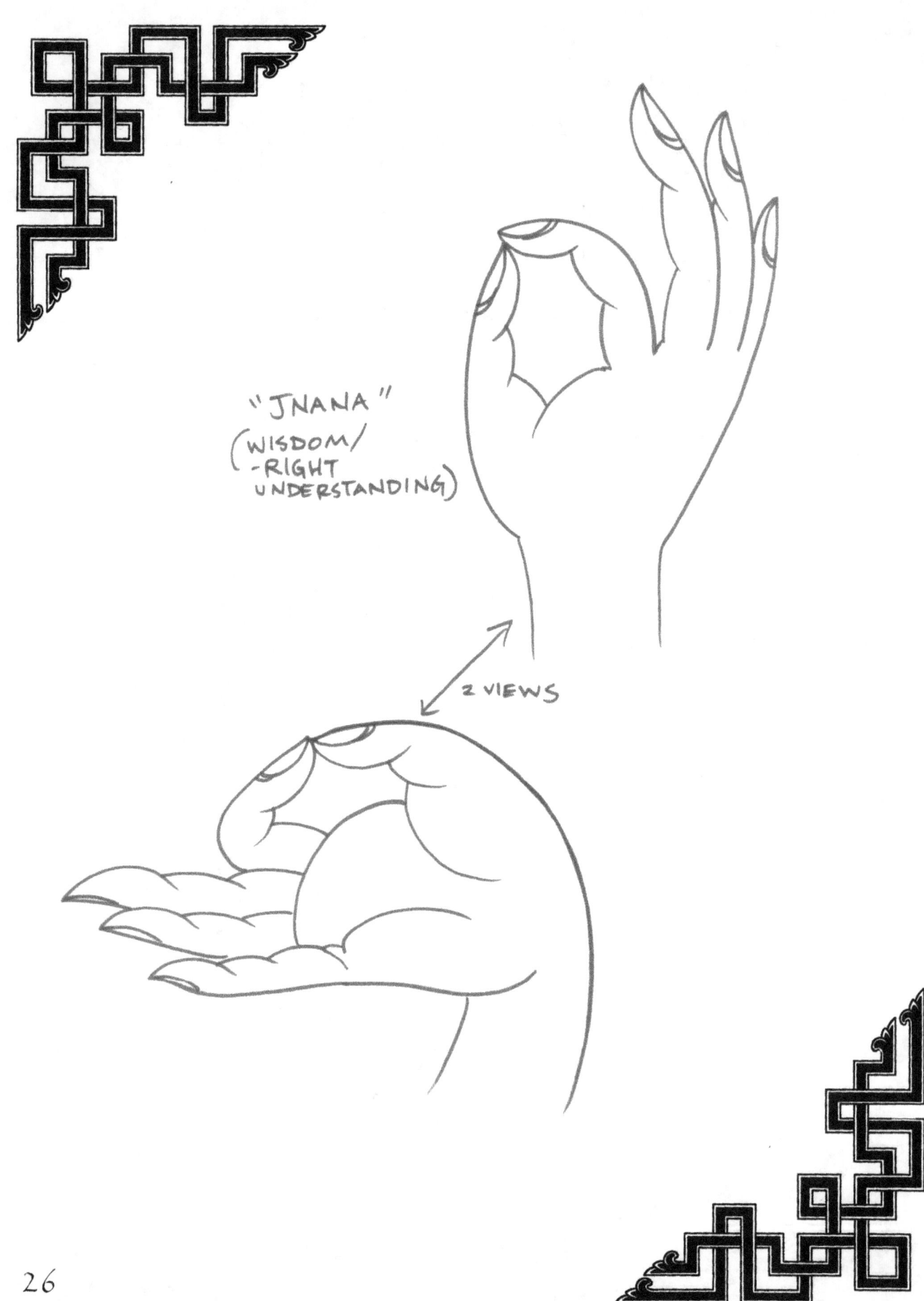

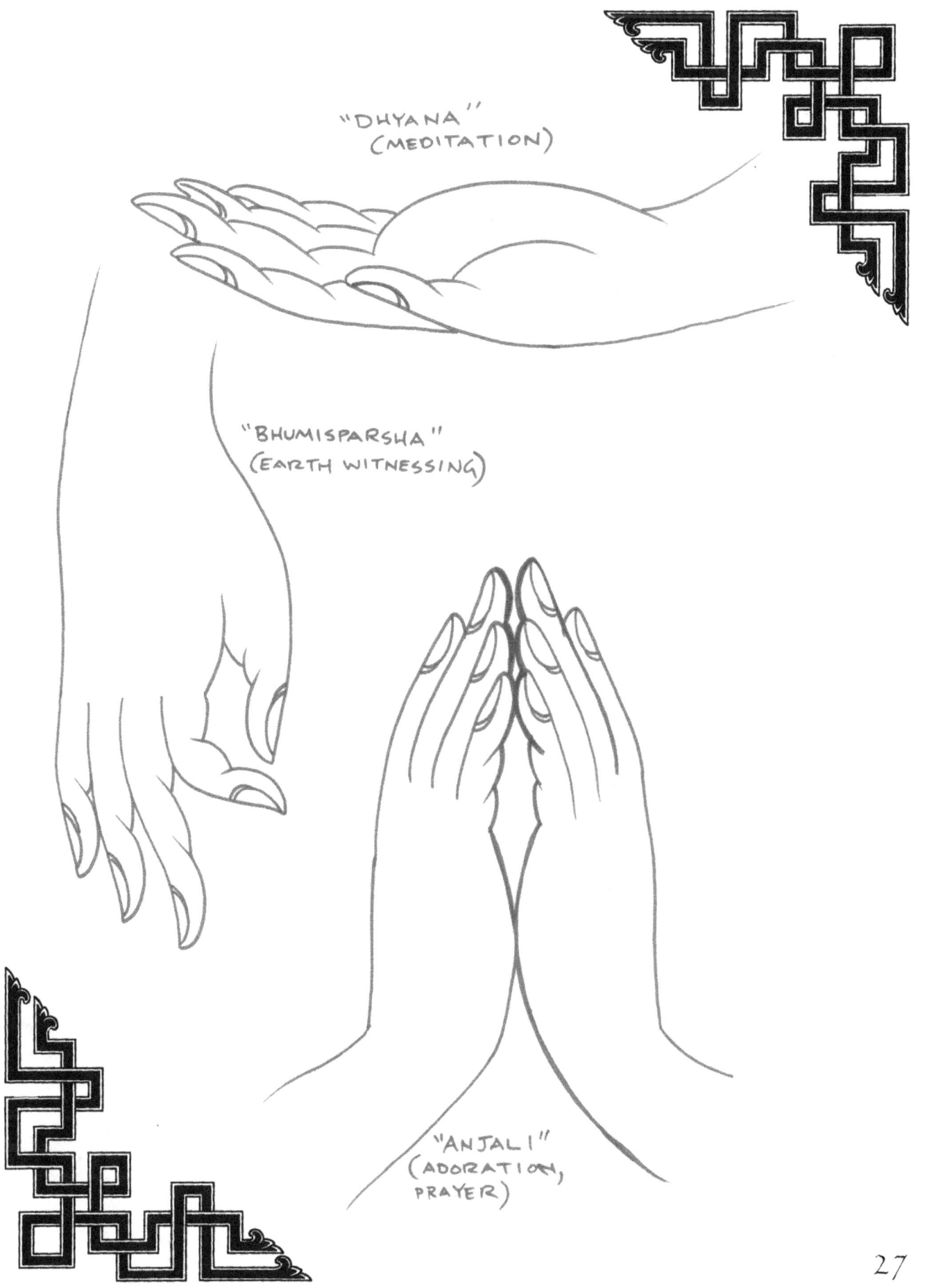

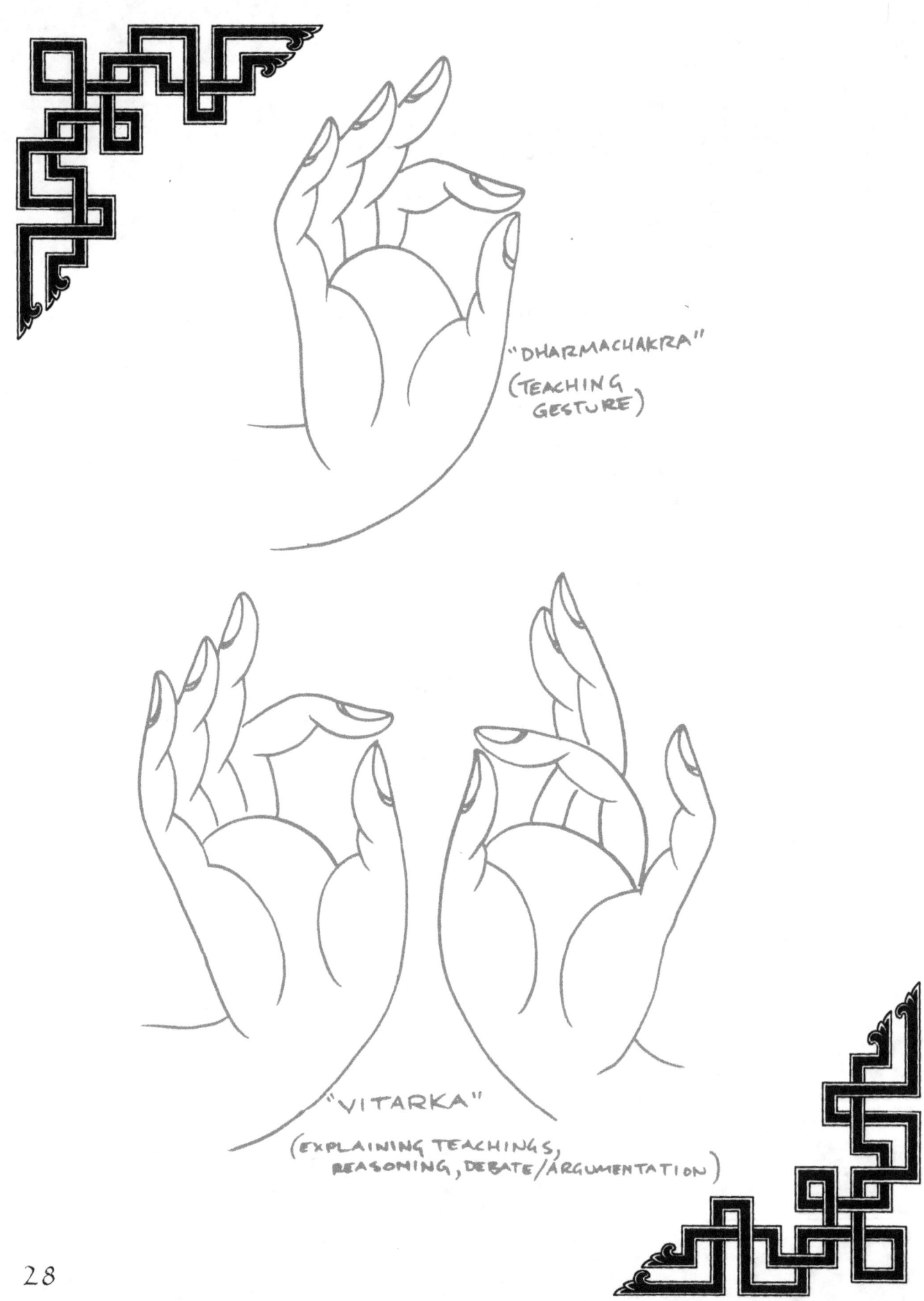

"DHARMACHAKRA" (TEACHING GESTURE)

"VITARKA" (EXPLAINING TEACHINGS, REASONING, DEBATE/ARGUMENTATION)

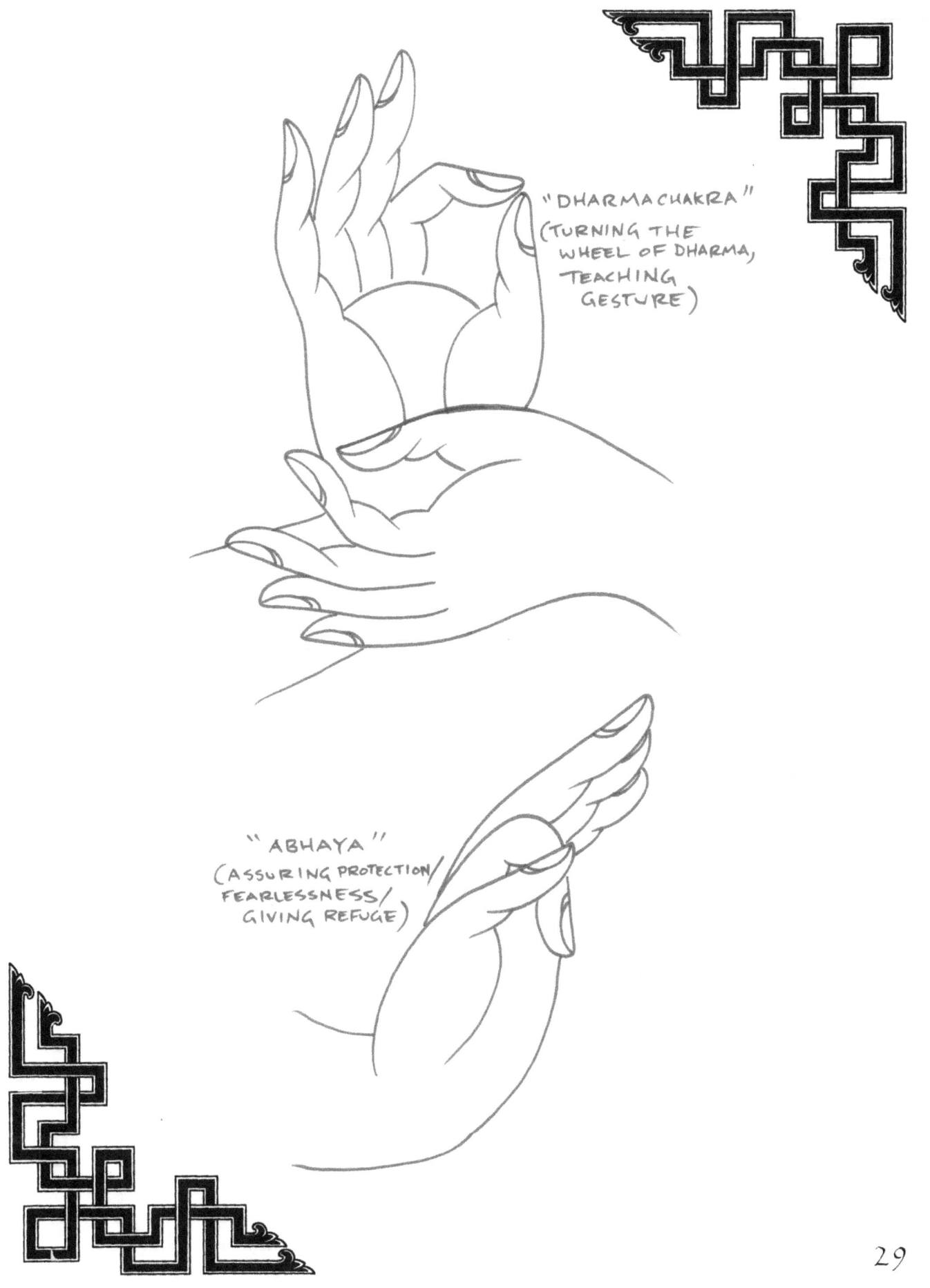

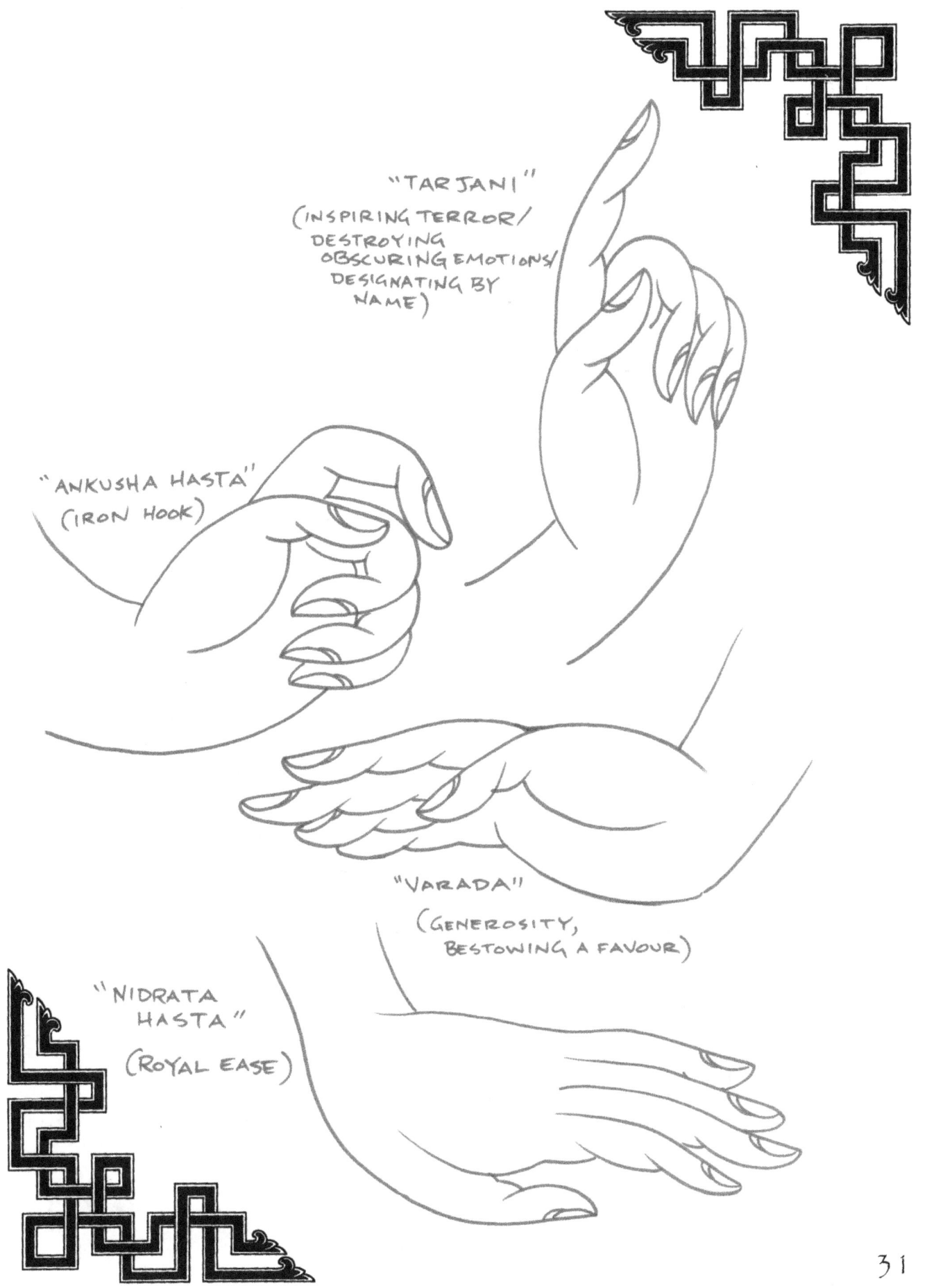

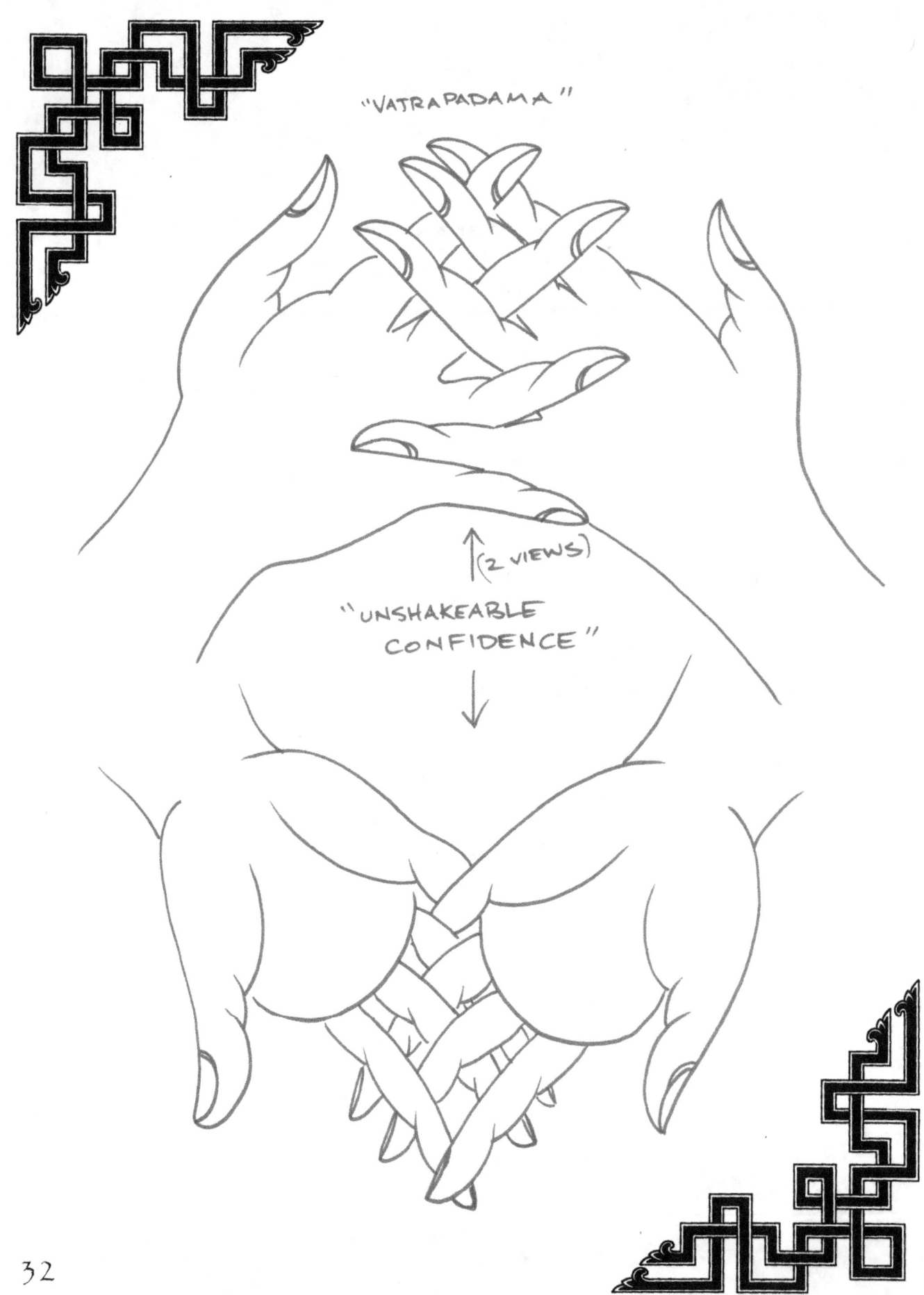

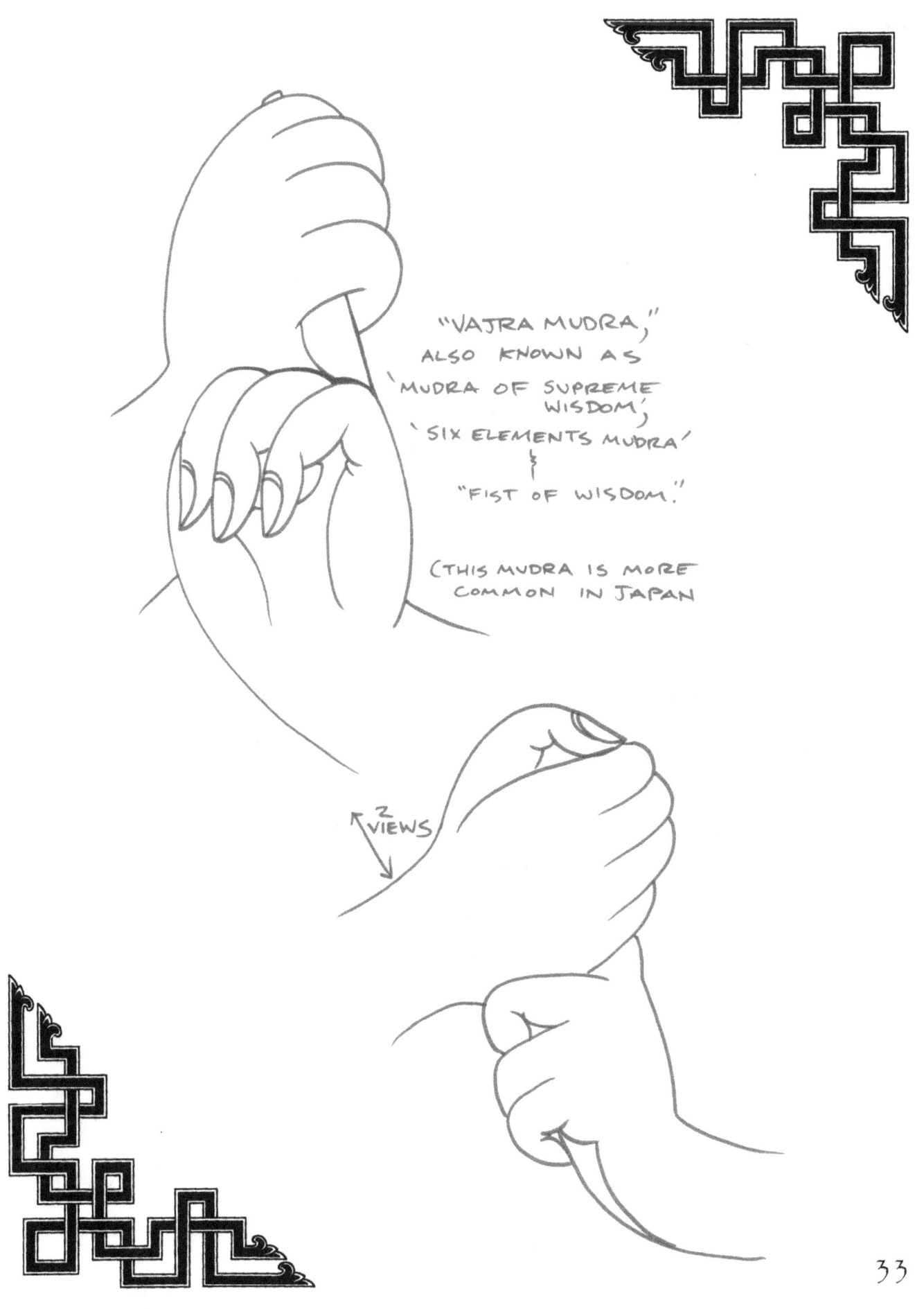

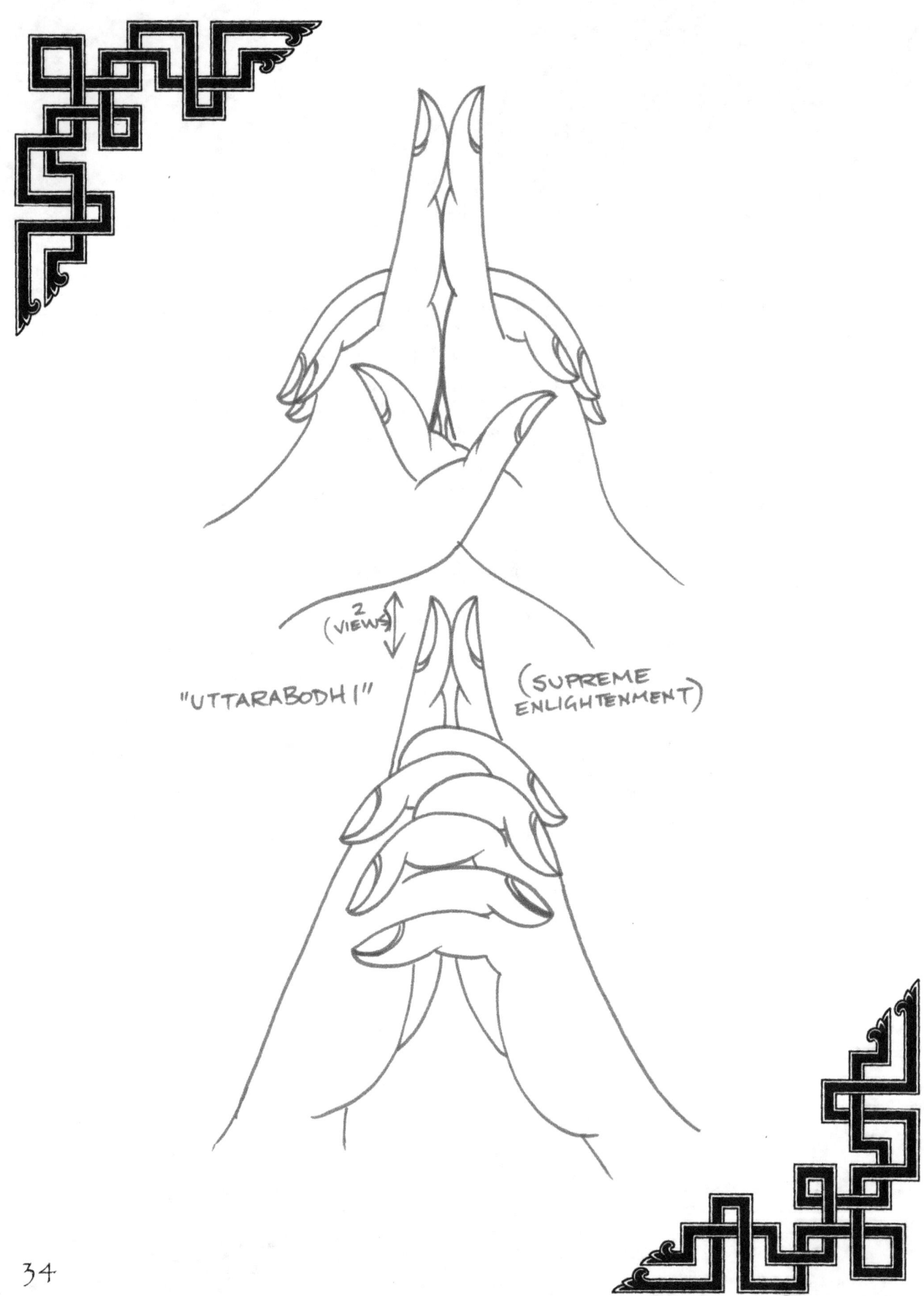

The Eight Auspicious Symbols

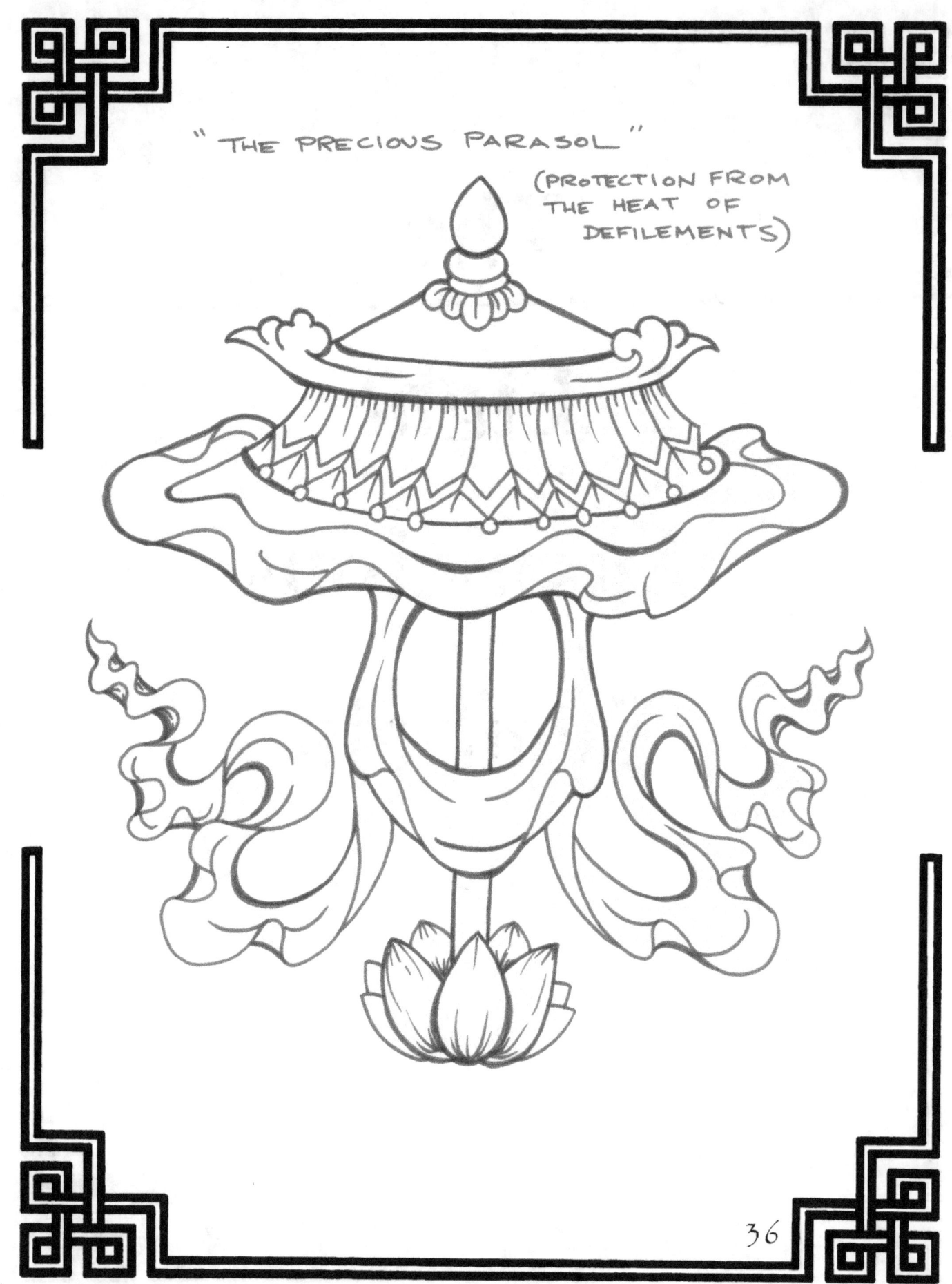

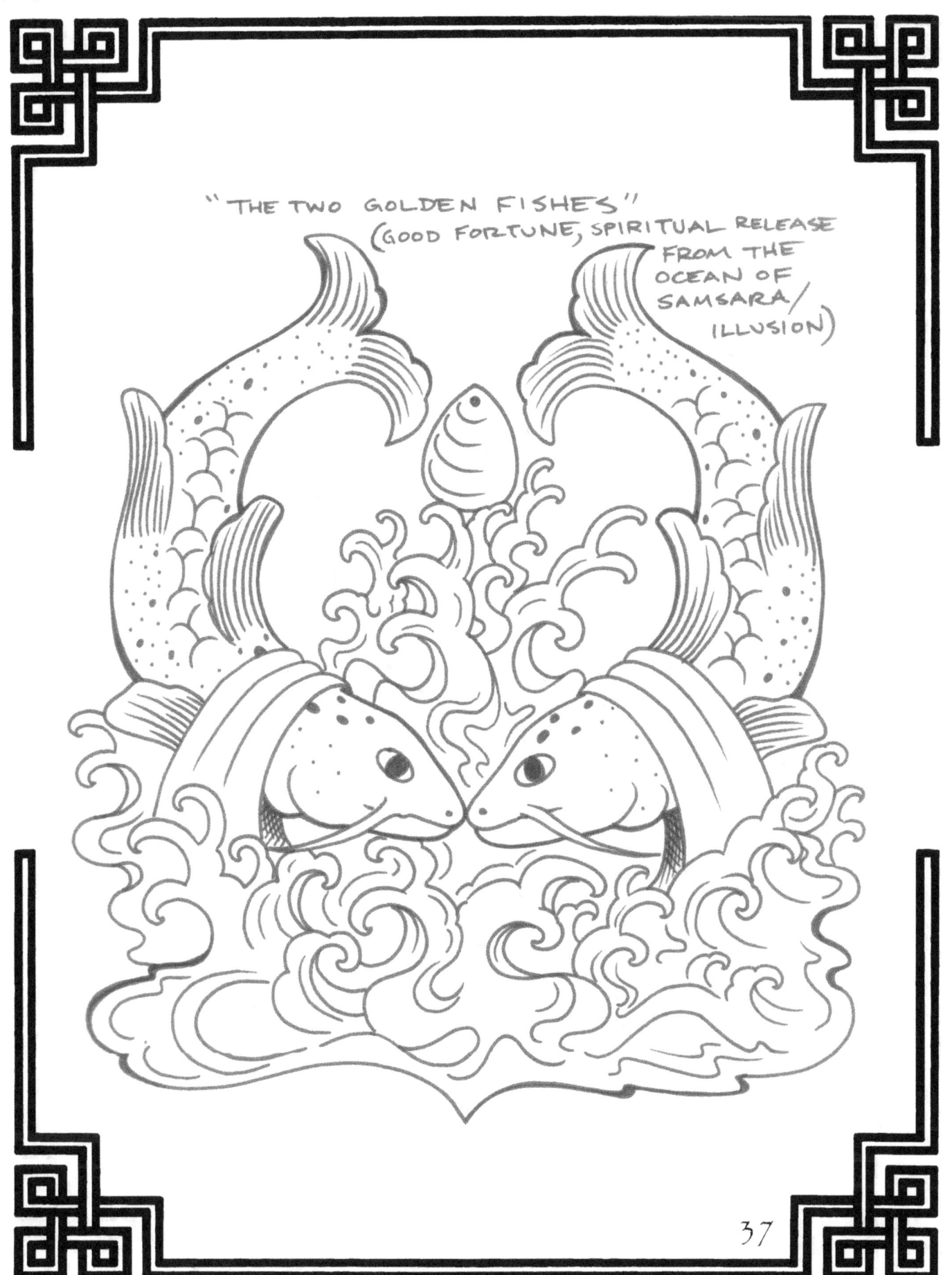

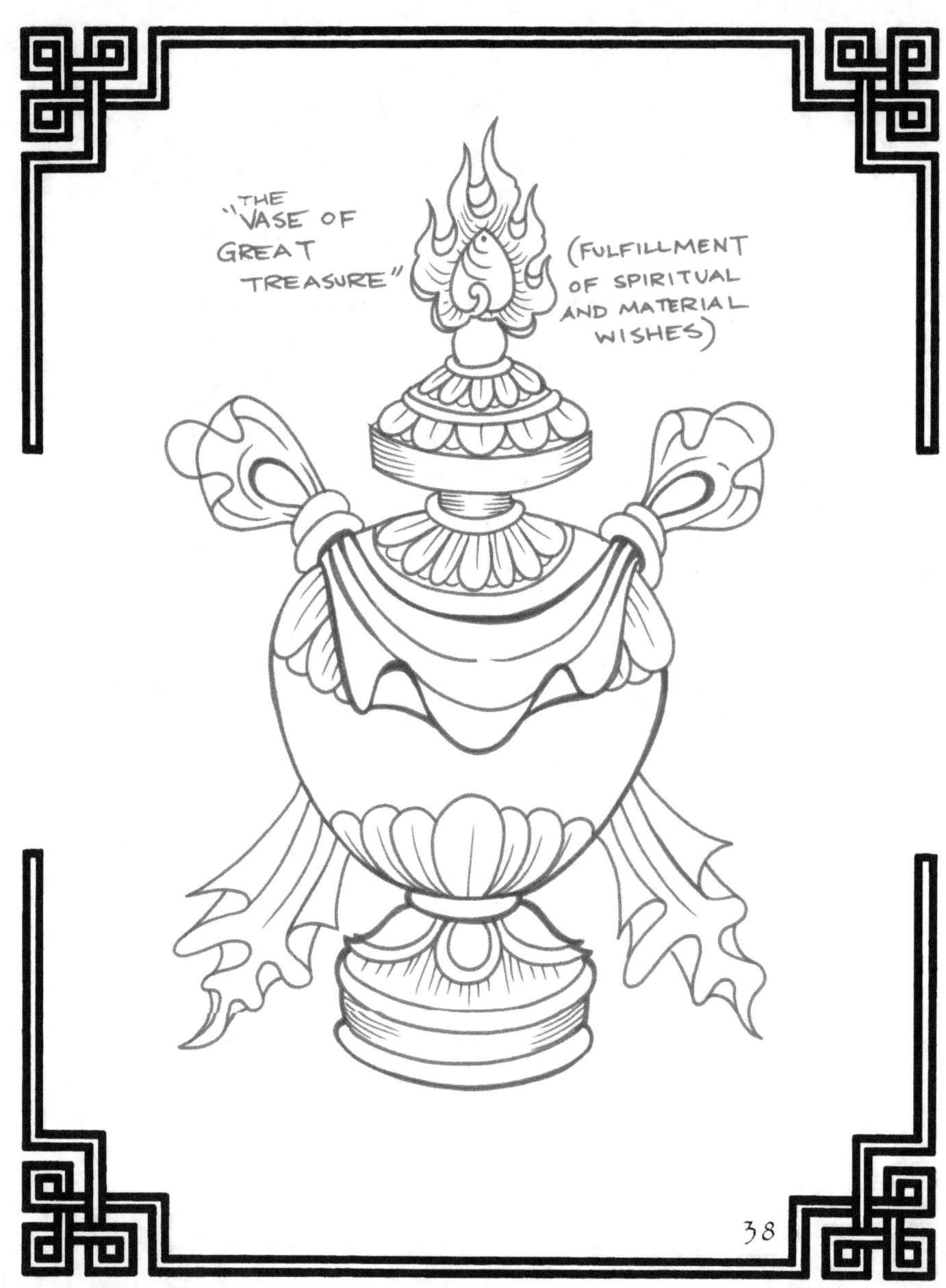

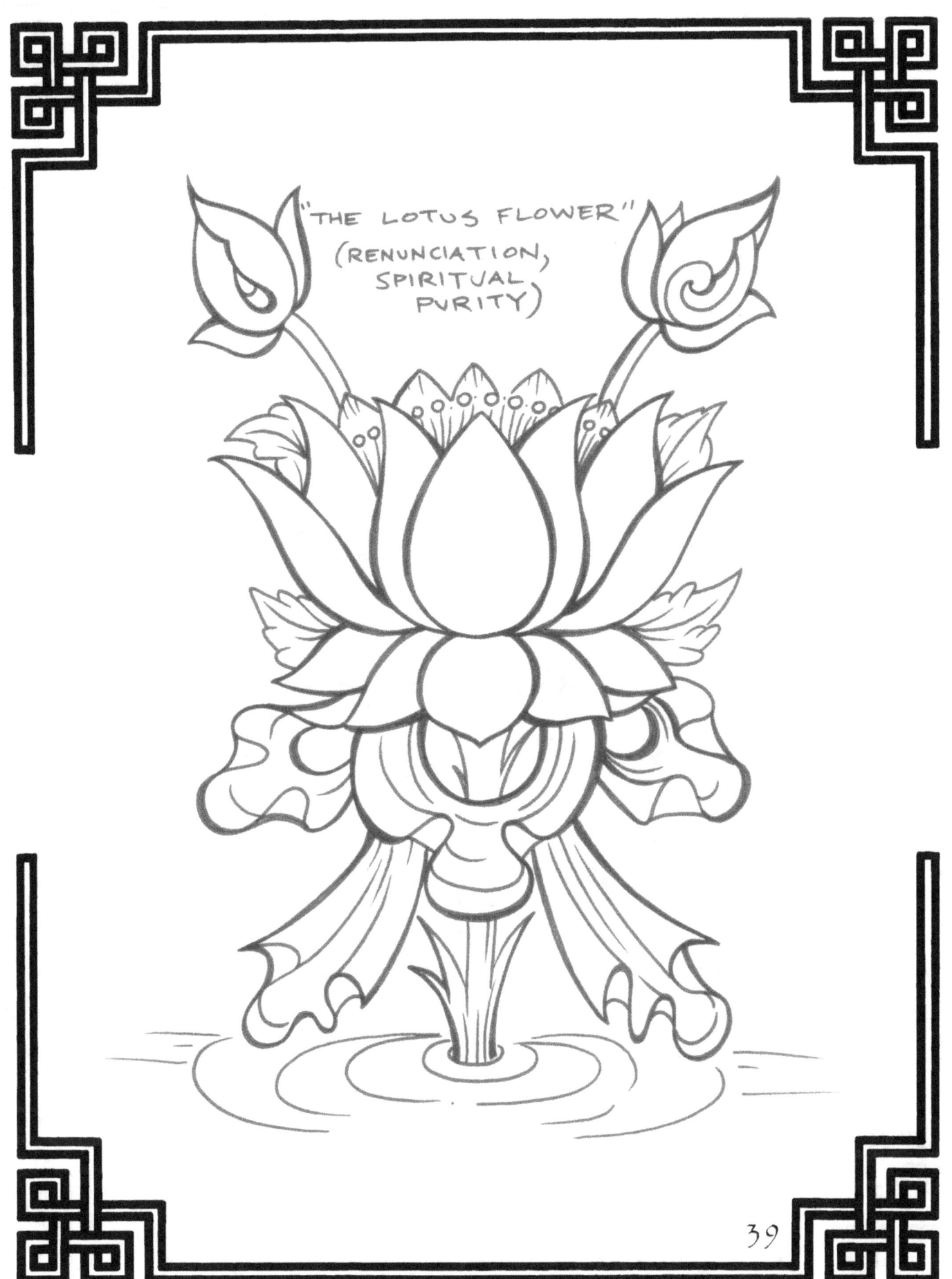

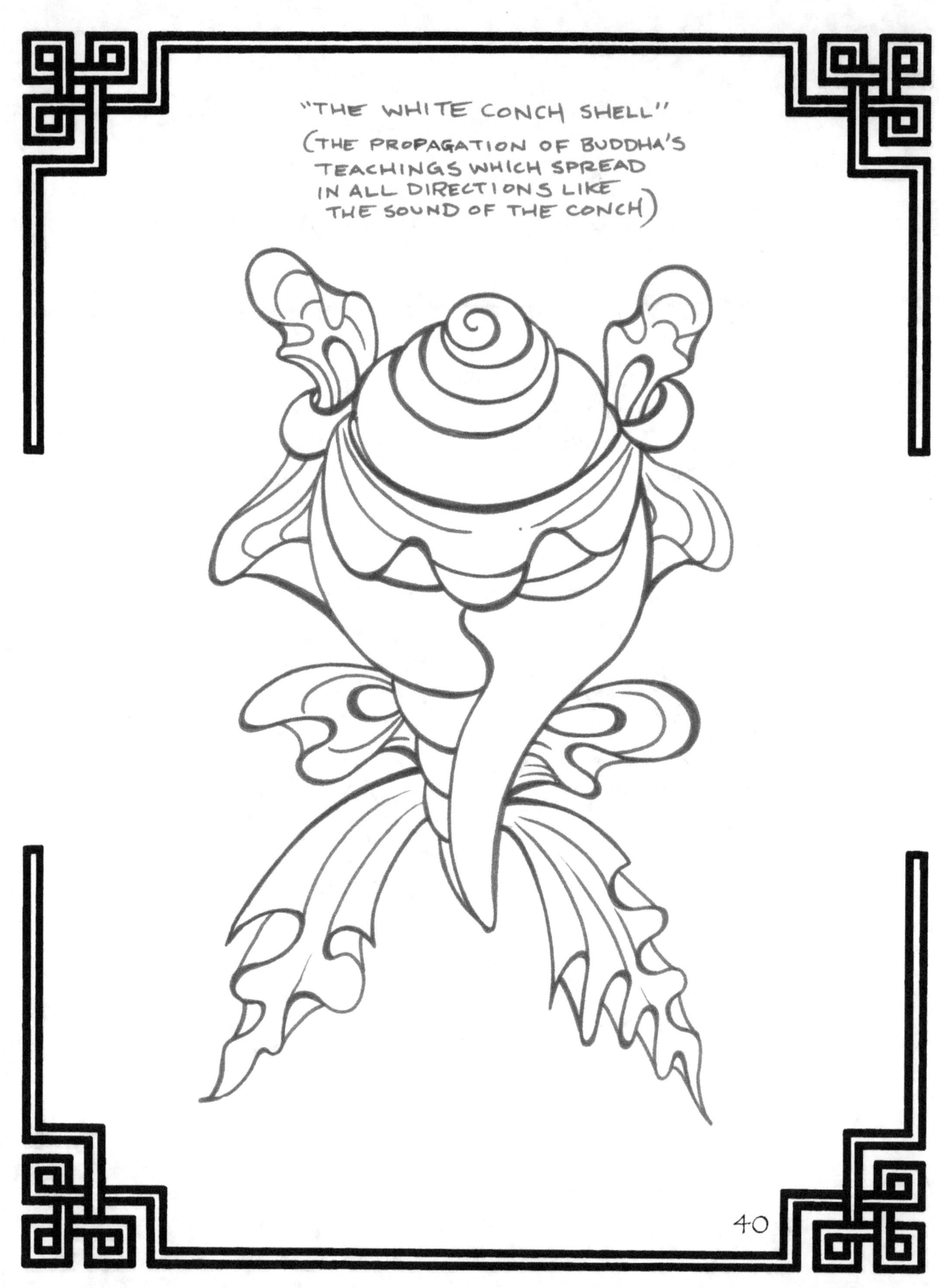

"THE WHITE CONCH SHELL"
(THE PROPAGATION OF BUDDHA'S TEACHINGS WHICH SPREAD IN ALL DIRECTIONS LIKE THE SOUND OF THE CONCH)

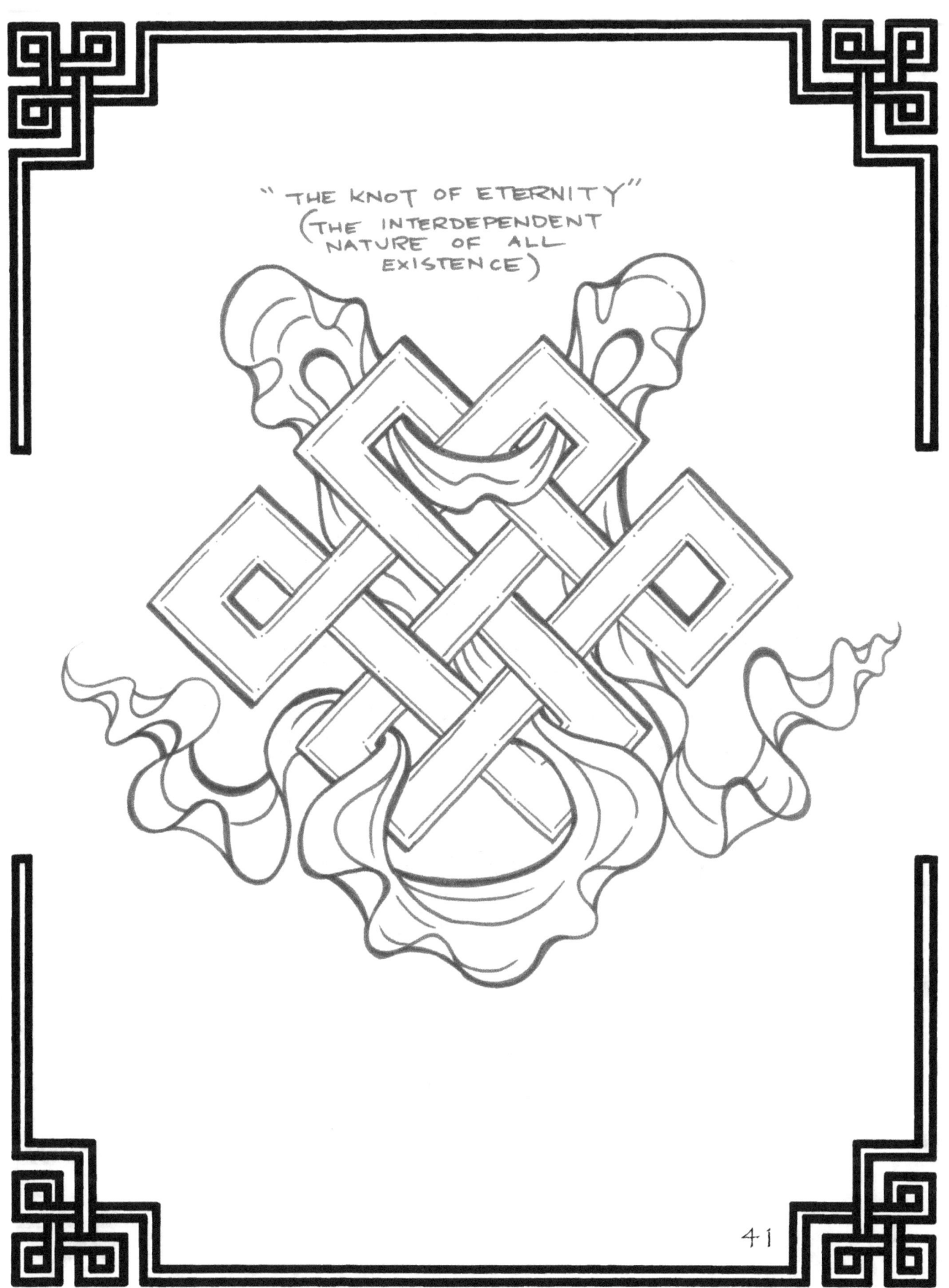

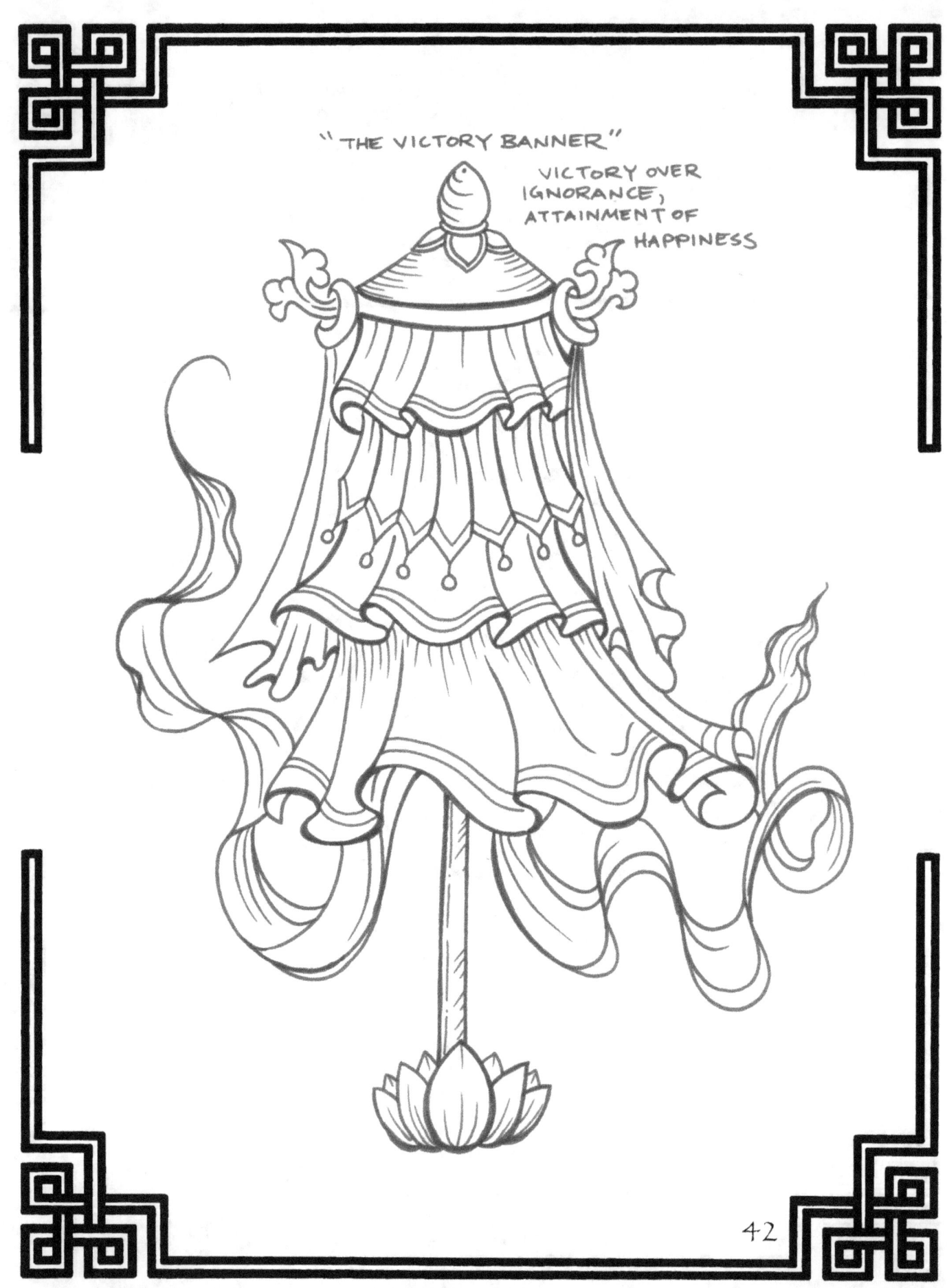

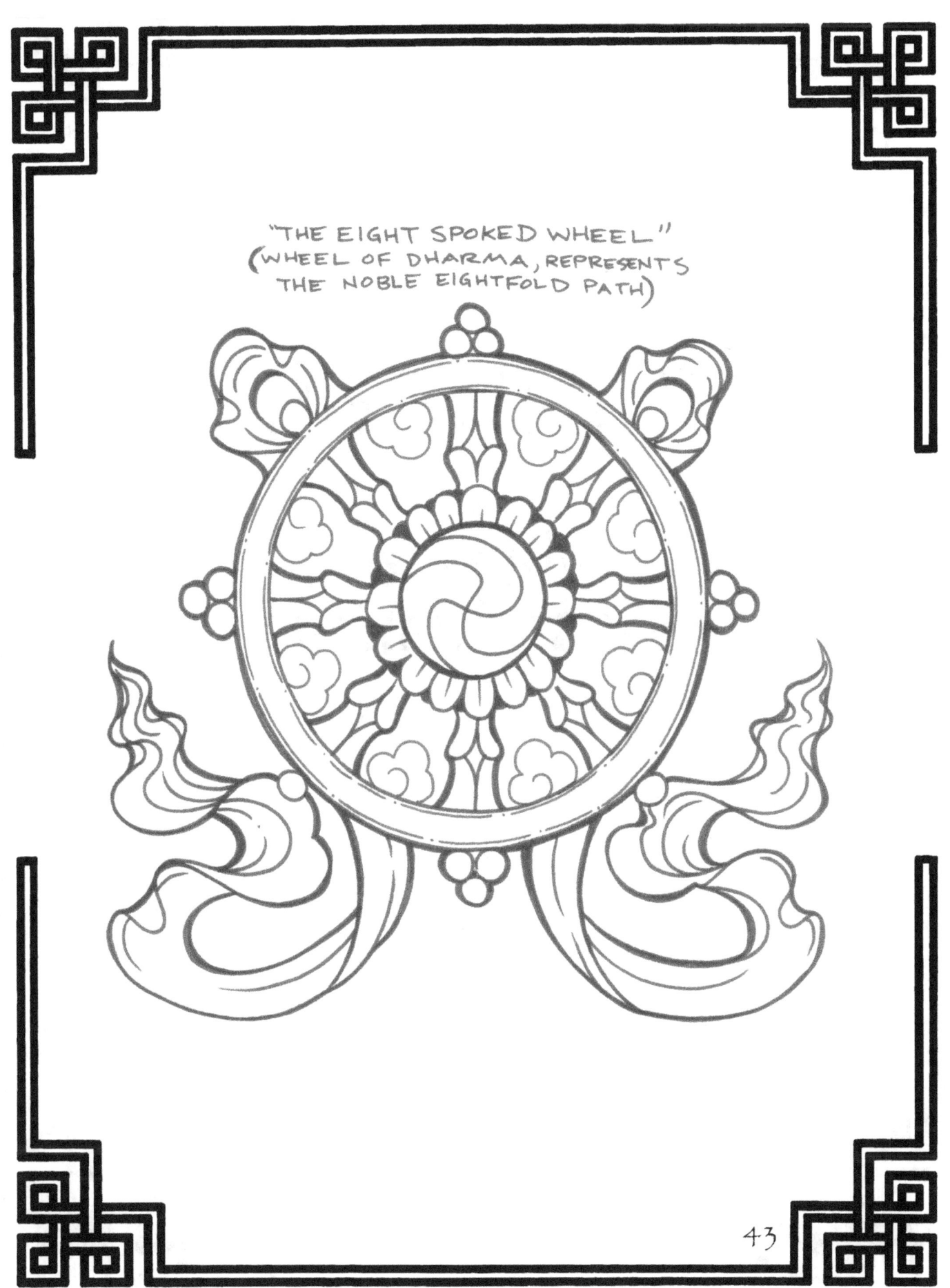

"THE EIGHT SPOKED WHEEL"
(WHEEL OF DHARMA, REPRESENTS THE NOBLE EIGHTFOLD PATH)

Mantras
&
Mantra Visualization

The Lotus, Moon Disk & Vajra

-From a syllable 'Pam" appears a Lotus throne, symbolizing Renunciation

-From a syllable "Ah" appears a moon disk, representing Bodhicitta

-From a syllable "Hum" appears a five spoked Vajra, representing the wisdom of emptiness/ultimate reality

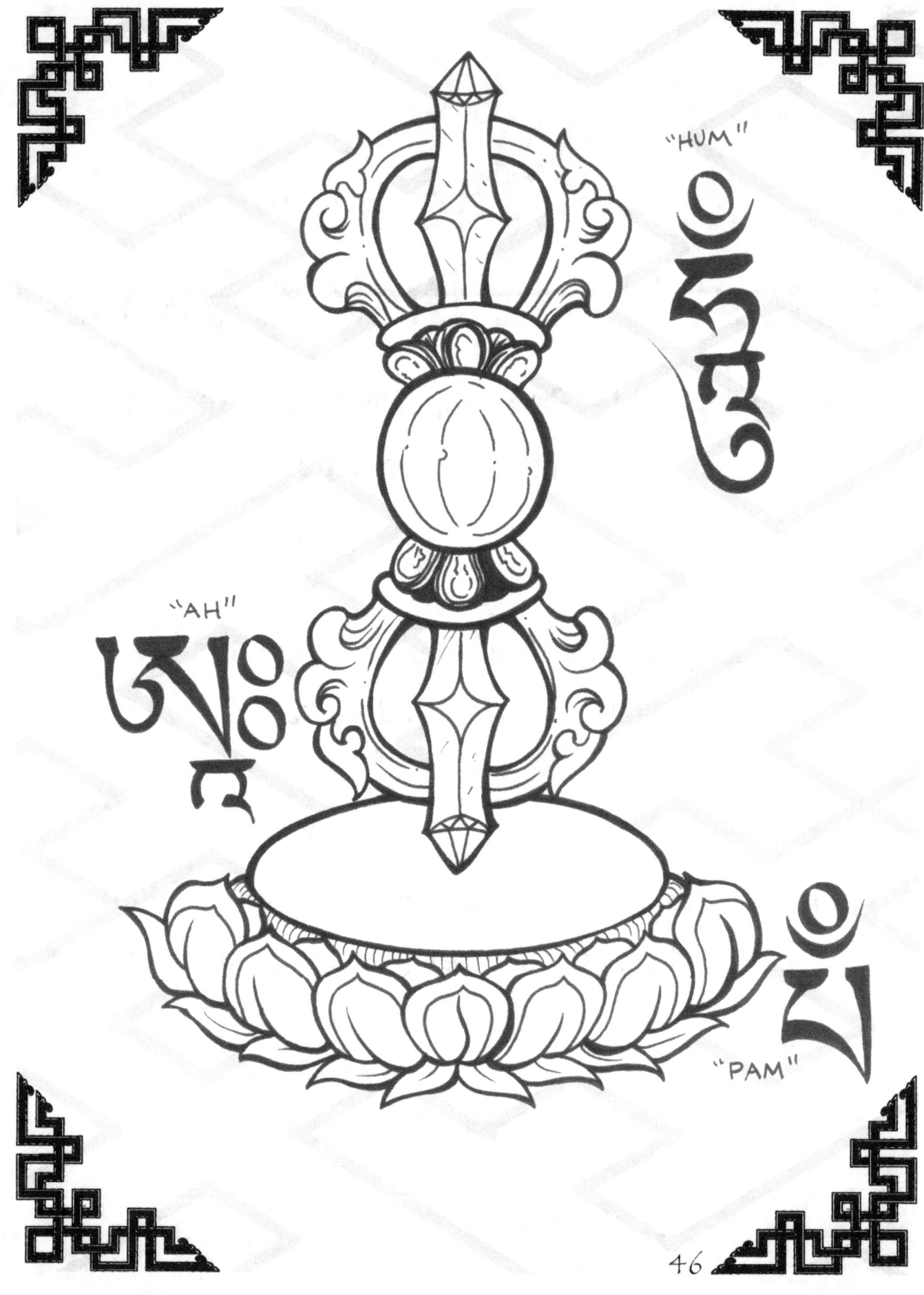

"100 SYLLABLE VAJRASATTVA MANTRA"

"OM VAJRA SATTO SAMAYA· MANU PALAYA· VAJRA SATTO TENOPA TISHTA· DRIDO ME BHAWA· SUTO KAYO ME BHAWA· SUPO KAYO ME BHAWA· ANU RAKTO ME BHAWA· SARWA SIDDHI ME PRAYANTSA· SARWA KARMA SUTSA ME· CHITAM SHRIYAM KURU HUM· HA HA HA HA HO· BHAGAVAN· SARVA TATHAGATA· VAJRA MAME MUNTSA· VAJRI BAWA· MAHA SAMAYA SATTO· AH HUM PHAT"

"VAJRASATTVA MANTRA"

"SHORT VAJRASATTVA MANTRAS"

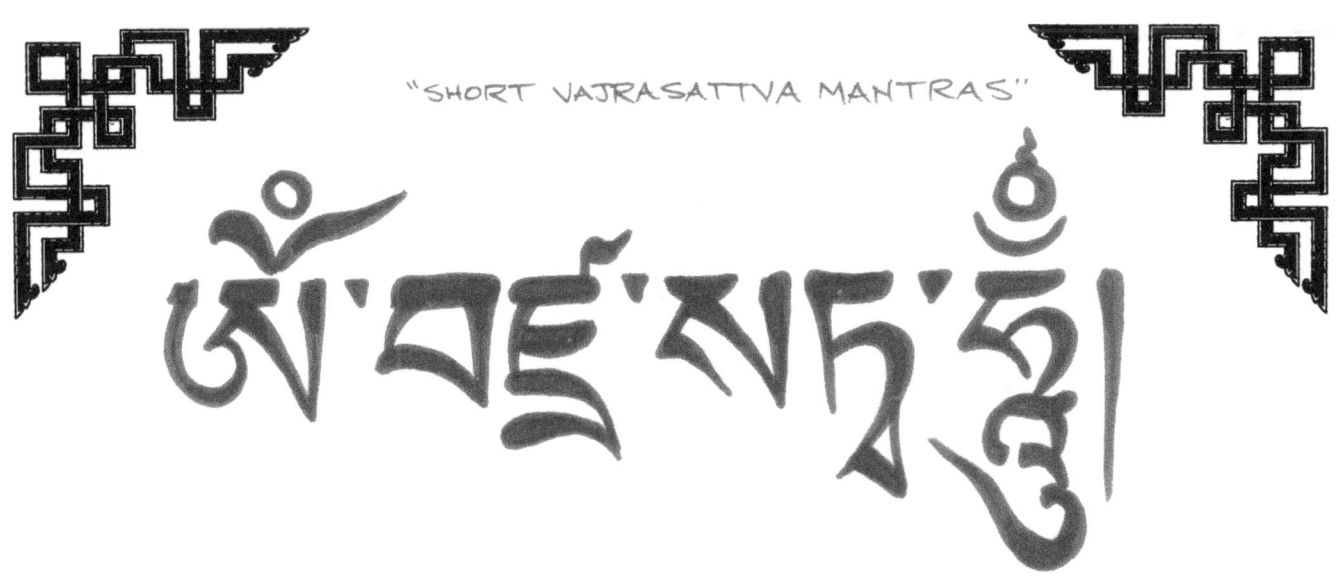

"OM VAJRA SATTVA HUM"
/BENZA

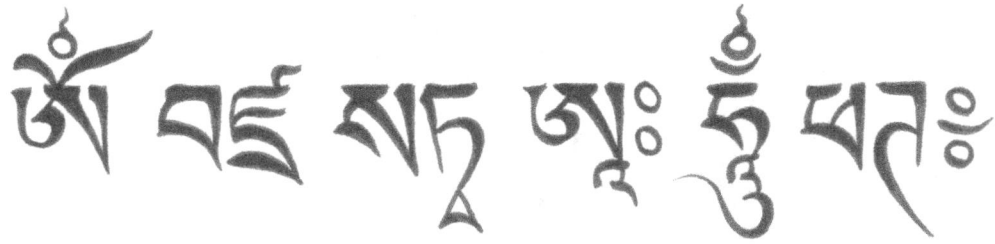

"OM VAJRA SATTVA AH HUM PHAT"
(BENZA)

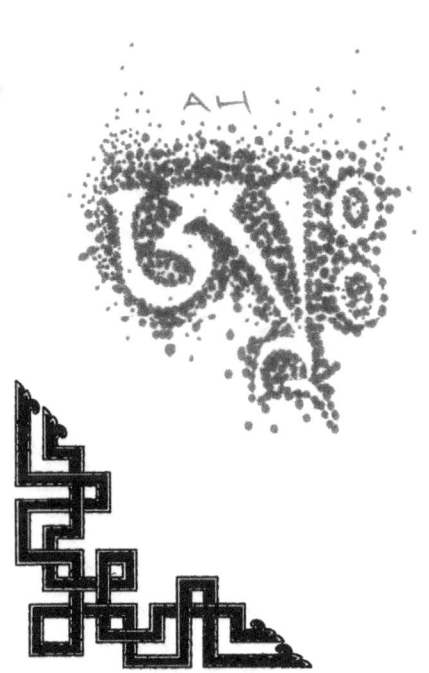
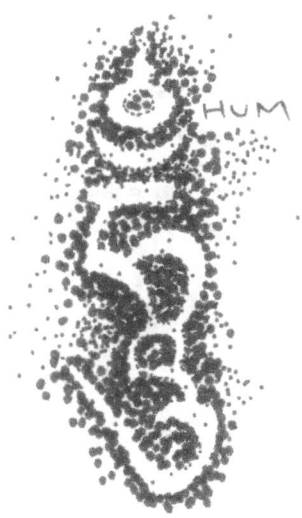

"OM"

"AH"

"HUM"

"PADMASAMBHAVA MANTRA"

"OM AH HUM VAJRA GURA PADMA SIDDHI HUM"
/BENZA

"WHITE TARA MANTRA"

"OM TARE TUTTARE TURE MAMA AYUH-PUNYA-JNANA-PUSTIM KURU SVAHA"

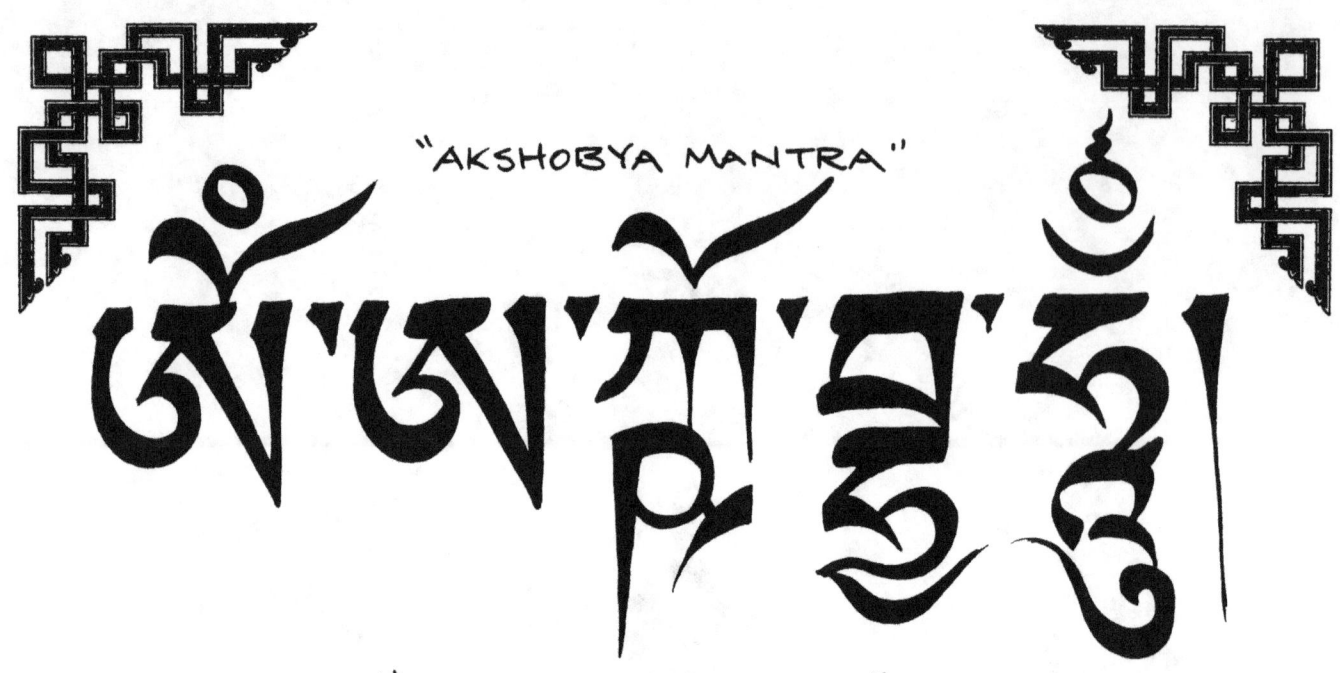

"AKSHOBYA MANTRA"

"OM AKSHOBYA HUM"

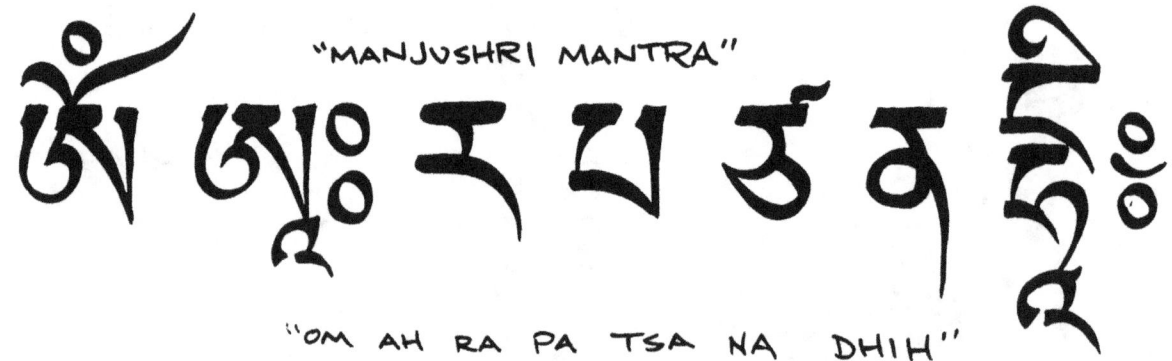

"MANJUSHRI MANTRA"

"OM AH RA PA TSA NA DHIH"

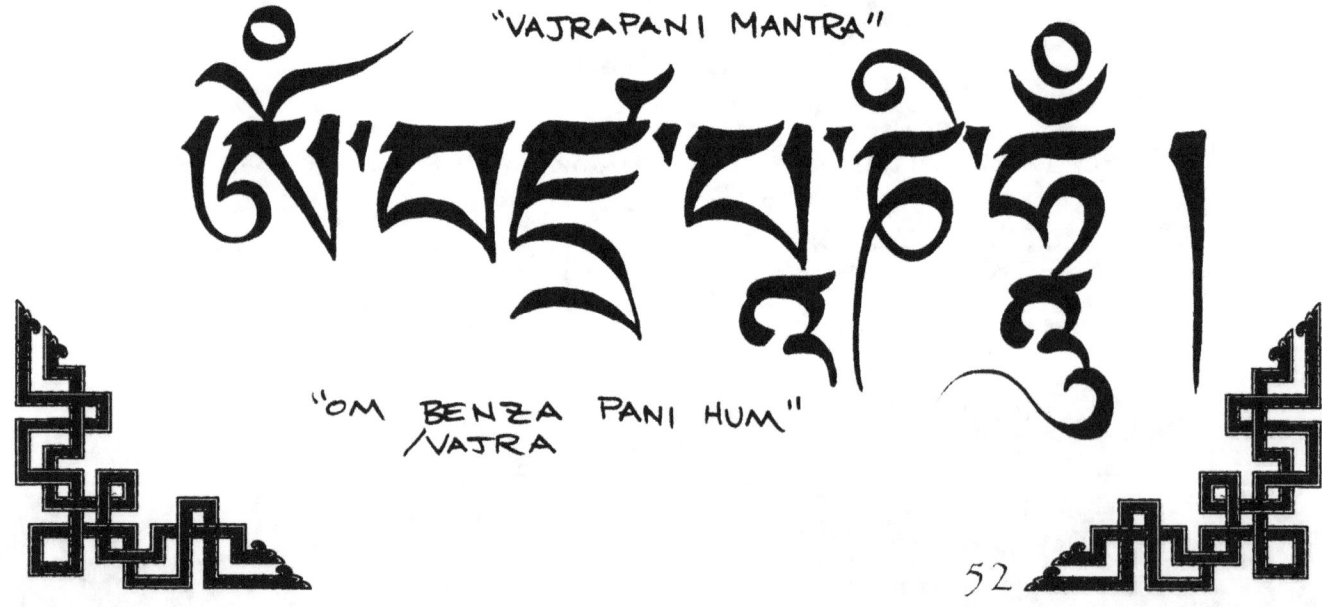

"VAJRAPANI MANTRA"

"OM BENZA PANI HUM"
/VAJRA

"GREEN TARA MANTRA"

"OM TARE TUTTARE TURE SVAHA"

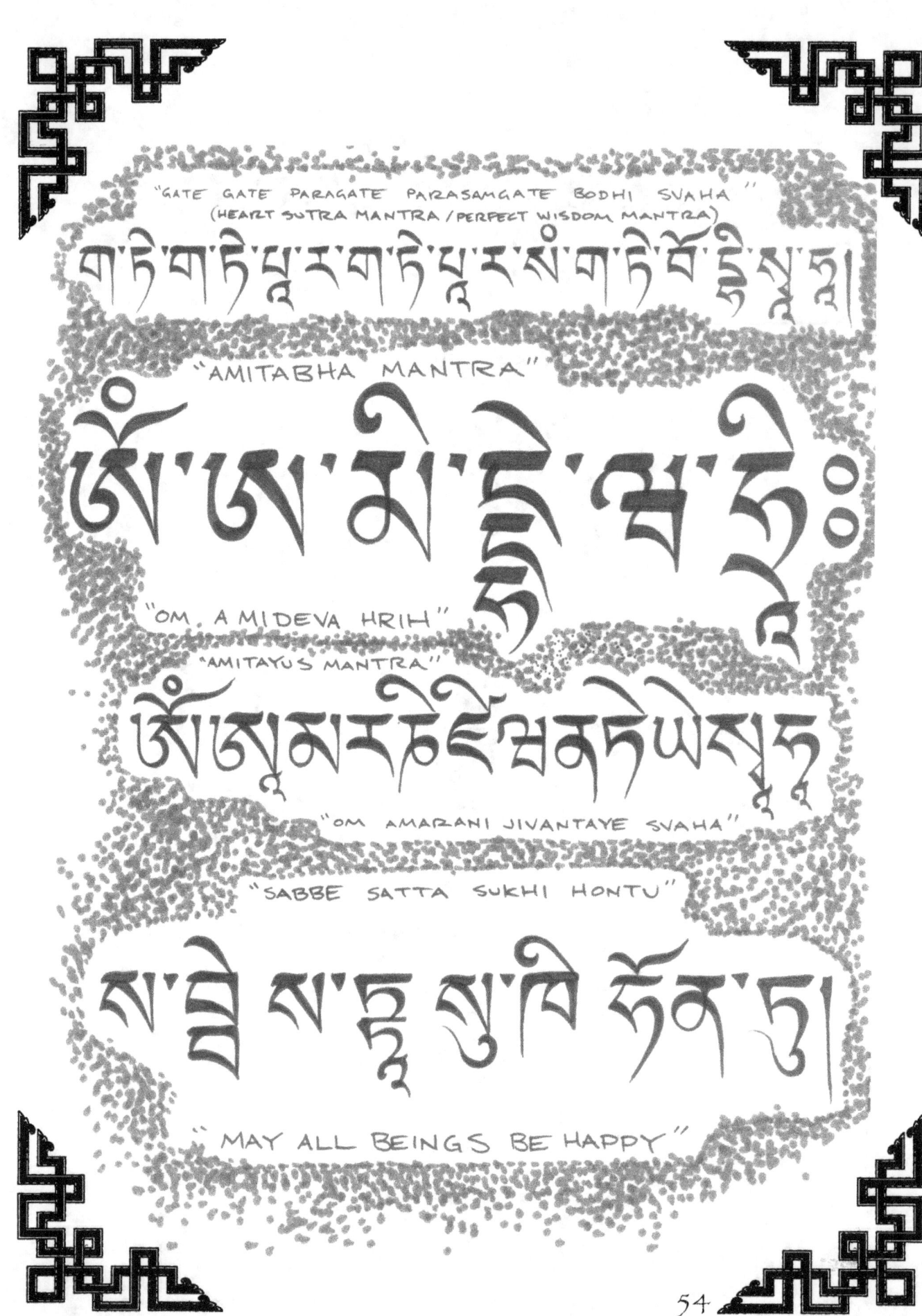

"MEDICINE BUDDHA MANTRA"

"TADYATHA OM BHEKHANDZYE BHEKHANDZYE MAHA BHEKHANDZYE [BHEKHANDZYE] RAJA SAMUDGATE SVAHA"

Mantra of Avalokiteshvara (Chenrezig)

(Explanation by Drepung Loseling Center for Tibetan Studies)
Mantras are brief, powerful prayers composed of sacred syllables. Om Mani Padme Hum, the mantra of Avalokiteshvara, the Buddha of Compassion, is the most popular of such prayers in Tibetan Buddhism. It is recited daily for purification, accumulation of merit, protection and spiritual realization.

Om Mani Padme Hum

(as explained by Drepung Loseling, Monastery of His Holiness the 14th Dalai Lama-Tenzin Gyatso)

Om-symbolizes the ordinary body, speech and mind of a person. It also symbolizes the pure exalted body, speech and mind of a Buddha

Mani-meaning jewel, symbolizes the method aspect of the path to enlightenment which is love and compassion.

Padme-meaning lotus, symbolizes the wisdom aspect of the path to enlightenment.

Hum-symbolizes the unity of method and wisdom

Thus, the six syllables Om Mani Padme Hum signify that through practice and meditation, we can transorm our impure body, speech and mind into the pure exalted body, speech and mind of a Buddha

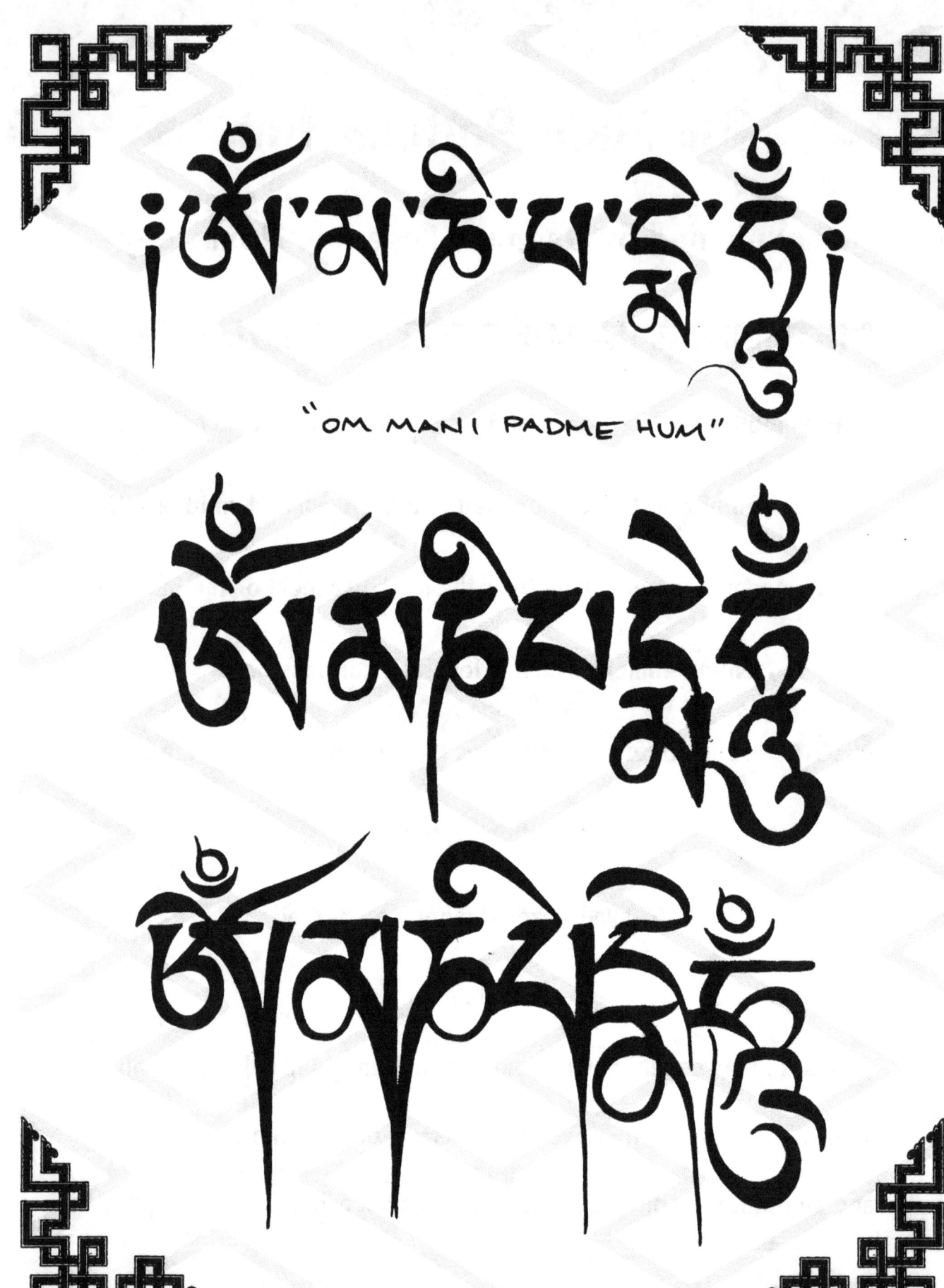

"OM MANI PADME HUM"

"OM MANI PADME HUM"

ཨོཾ་མ་ཎི་པདྨེ་ཧཱུྃ༔

ༀ་མ་ཎི་པདྨེ་ཧཱུྂ།

ༀ་མ་ཎི་པདྨེ་ཧཱུྂ

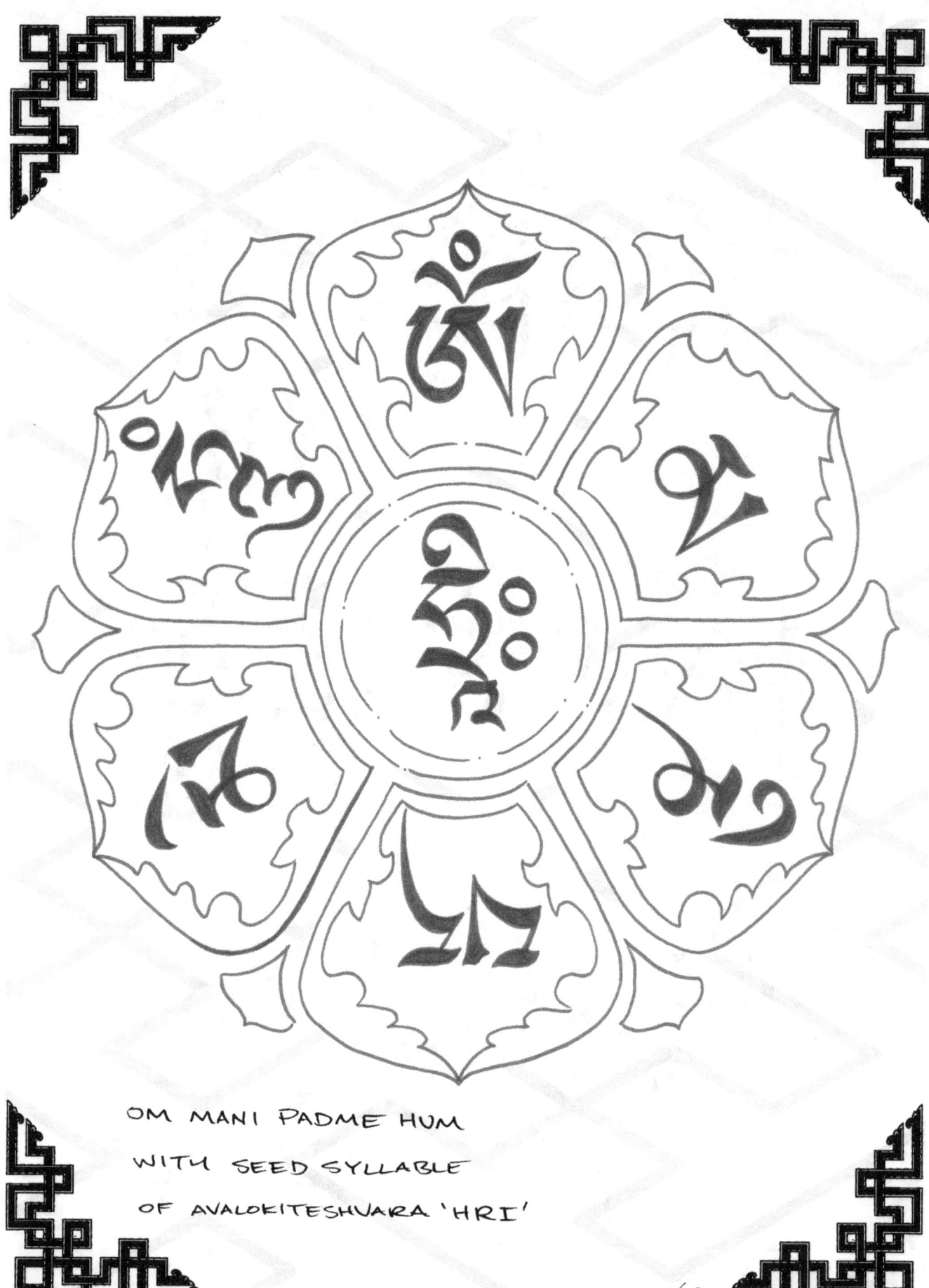

OM MANI PADME HUM WITH SEED SYLLABLE OF AVALOKITESHVARA 'HRI'

Please visit us on the web at:

www.facebook.com/SouthSeasDharma

We have Tibetan Ritual Objects, Meditation Supplies,
Posters, Prints and more

For more books, check out
http://astore.amazon.com/southseasdharma-20

www.southseasdharma.com
(coming soon)

www.ingramcontent.com/pod-product-compliance
Lightning Source LLC
Chambersburg PA
CBHW080828170526
45158CB00009B/2538